PAINTING WITH YOUR ARTIST'S BRAIN

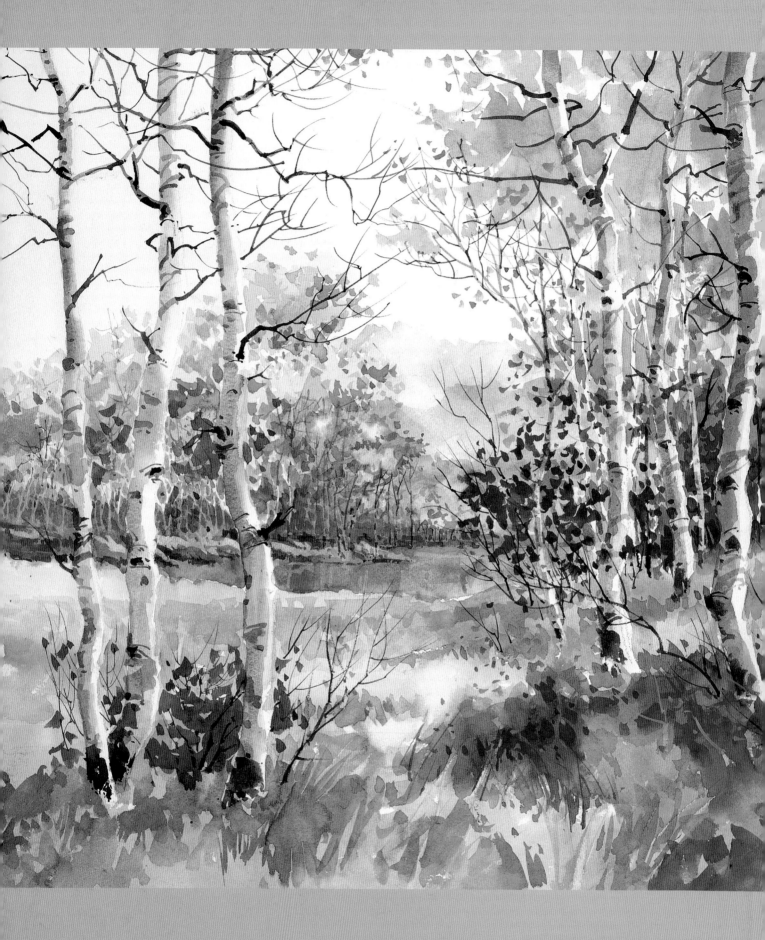

painting with your
ARTIST'S
Brain

Learn to paint what you see—
not what you think you see

Carl Purcell

NORTH LIGHT BOOKS
CINCINNATI, OHIO
www.artistsnetwork.com

ABOUT THE AUTHOR

Carl Purcell has taught painting and drawing at Snow College in central Utah for more than 27 years, and serves as department chairman there. He helped develop and still teaches an annual two-week summer watercolor workshop at the college. It has become very popular, drawing people from throughout the neighboring states.

Carl is a signature member of the National Watercolor Society and has received numerous awards for his watercolors. He is a popular workshop instructor, teaching in Utah, Nevada, Wyoming, Colorado, California, Oregon and Great Britain. His artwork appears in many corporate and private collections and has been featured in *The Artist's Magazine* and *Splash 1* (North Light Books, 1991).

Carl is the father of five children, and proud grandfather to eleven grandchildren. He lives in Manti, Utah, with his wife, Nan.

Art from pages 2-3:

AUTUMN GLOW ▸ Watercolor ▸ 28" × 30" (71cm × 76cm)

Painting With Your Artist's Brain. Copyright © 2004 by Carl Purcell. Manufactured in China. All rights reserved. No part of this book may be reproduced in any form or by any electronic or mechanical means including information storage and retrieval systems without permission in writing from the publisher, except by a reviewer who may quote brief passages in a review. Published by North Light Books, an imprint of F+W Publications, Inc., 4700 East Galbraith Road, Cincinnati, Ohio 45236. (800) 289-0963. First Edition.

Other fine North Light Books are available from your local bookstore, art supply store or direct from the publisher.

08 07 06 05 04 5 4 3 2 1

Library of Congress Cataloging in Publication Data

Purcell, Carl L. (Carl Lee),
 Painting with your artist's brain/ Carl Purcell. — 1st ed.
 p. cm
 Includes index.
 ISBN 1-58180-397-4 (hc. : alk. paper)
 1. Painting—Psychological aspects. I. Title.

ND2420.P87 2004
751.42'2—dc22

2003059964

Edited by Stefanie Laufersweiler and Christina Xenos
Designed by Wendy Dunning
Production art by John Langan
Production coordinated by Mark Griffin

Metric Conversion Chart

TO CONVERT	TO	MULTIPLY BY
Inches	Centimeters	2.54
Centimeters	Inches	0.4
Feet	Centimeters	30.5
Centimeters	Feet	0.03
Yards	Meters	0.9
Meters	Yards	1.1
Sq. Inches	Sq. Centimeters	6.45
Sq. Centimeters	Sq. Inches	0.16
Sq. Feet	Sq. Meters	0.09
Sq. Meters	Sq. Feet	10.8
Sq. Yards	Sq. Meters	0.8
Sq. Meters	Sq. Yards	1.2
Pounds	Kilograms	0.45
Kilograms	Pounds	2.2
Ounces	Grams	28.3
Grams	Ounces	0.035

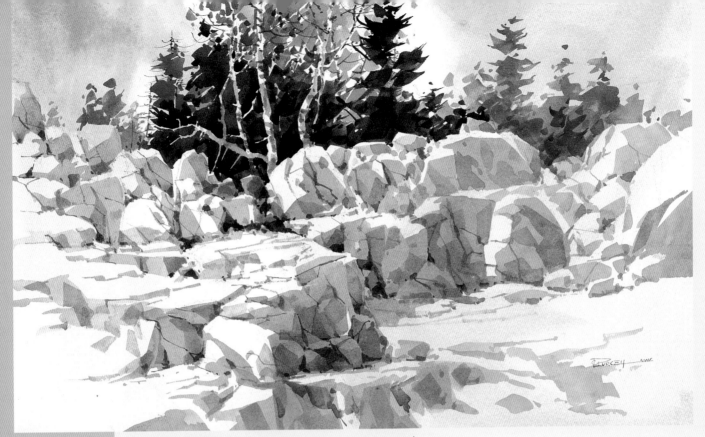

RIGHT FROM THE ROCKS ▸ Watercolor ▸ 14" × 21" (36cm × 53cm)

This book is dedicated to my wife, Nan, whose encouragement, critiques and faith in me were followed by a willingness to shoulder a lot of extra work so that I would be free to write and create the art for this book. I never could have done this without her. In many ways this is as much her book as it is mine. This book, my workshops and my life are vastly improved because of Nan's involvement.

ACKNOWLEDGMENTS

I give thanks to God whose divine help has lifted me beyond my early aspirations, fears and self-doubts and has made this book possible.

A special thanks goes to my close friends Patrick Lynch, for insisting that I do it now, and Colleen Bailey, for her belief in me and for her love of my art. I would like to express my gratitude to my brother, Roy, who inspired me with his enthusiasm for art. Thanks also to George Durrant, a dear friend and writer, for his many words of encouragement and faith in my ability to do this; and also to Adam Larsen and Brad Taggart, my fellow art instructors who have shouldered extra responsibilities in order to allow me to meet my deadlines. In addition, Adam was an invaluable help with the photography.

Thanks to my editor Stefanie Laufersweiler for her helpful suggestions and patience when problems of production arose.

And finally, thanks to a wonderful group who have given me unending support—my children and their spouses. Rhodri and Anne, thanks for your faith in me; Roanne and Cliff, thanks for saving the day with late-night trips for film developing; Ranita and Brian, I wish I were as great as you think I am; Randon and Erin, thanks for the computer tech support; and Rannoch, thanks for making every effort seem worth it.

And to all the workshop friends who have told me through the years, "You need to put this in a book," thanks.

Table of Contents

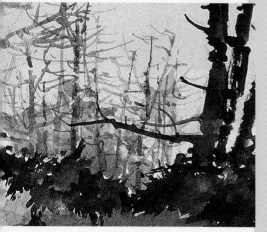

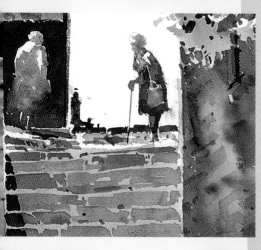

CHAPTER 1

developing GOOD TECHNIQUE 12

Before you can train your artist's brain to see correctly, you need to know good basic techniques for laying down paint on paper.

CHAPTER 2

the TWO BRAINS 30

Meet your intellectual brain and artist's brain. Learn to defeat the enemy within by becoming visually articulate.

CHAPTER 3

seeing SHAPES 44

Discover the qualities of interesting shapes using their silhouettes. Practice altering mundane shapes to transform them into exciting ones.

CHAPTER 4

seeing the SHAPE OF SPACE 60

Learn to design the shape of space around an object. Practice creating shapes of space to add visual impact to your subjects.

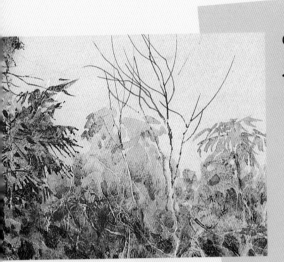

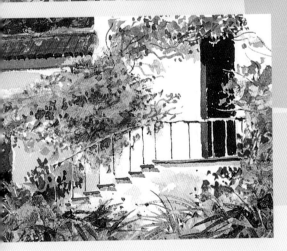

Introduction

The earliest art activity I can recall doing was watching in fascination as a line magically appeared behind the point of the pencil I was holding, and following it everywhere it went. My mother moved me away from the wall and gave me some paper, and I have been fascinated ever since with the marks art tools make. I am awed that those marks can convey emotions, and that I can express so much more eloquently with them rather than language, how I feel about the world around me. That is why I paint: to express my joy in living and experiencing the beauty that I find in God's creations.

My sole purpose in writing this book is to help you overcome the obstacles that may have prevented you from having a fully successful and satisfying experience in painting with the wonderful, energetic, mysterious and compelling medium of watercolor.

Years of teaching college art classes and workshops and judging art exhibitions have made me aware of universal problems that hinder artistic development in students of all ages. In my drawing classes I began to isolate those problems and found their source to be in our intellectual brain, not in lack of talent. Instead of seeing with our visual brain, or artist's brain, our interpretation of the subject is clouded by our own intellect. My teaching approach grew out of that discovery. It has been exciting for me to see students make sudden leaps in ability because of this approach, instead of making agonizingly slow progress. I hope you find in this book something that will help you.

As a youth I spent endless hours hiking through the rock canyons near my childhood home in Arizona. In nature I experienced a spiritual fulfillment that I felt nowhere else. I love drawing and painting people and many other subjects, but I am still irresistibly drawn to nature as a great inspiration for painting. Therefore, many of the paintings you will see in this book are nature-related.

My wish is that this book might help increase the frequency of your successes and give you encouragement to continue your journey in watercolor.

HIGHLAND CROFT, SCOTLAND ▸ Watercolor ▸ 28" × 30" (71cm × 76cm)

Materials and studio suggestions

Paper

There are numerous brands of watercolor paper. What makes one preferable to another is primarily determined by the individual artist's techniques. My paper of choice is Arches 140-lb. (300gsm) rough, for its texture and durable surface.

If not stretched beforehand, watercolor paper can buckle and warp as the applied paint dries. To prepare the paper for painting, I soak it in water for about ten minutes, then staple it down to one of my painting boards with an office stapler. My boards are made of 12-inch (30cm) or ¾-inch (20mm) foam-core board that have been covered with cotton canvas glued down with carpenter's glue and painted with a few coats of latex house paint. I have found this board provides enough body for the staples so they will not pull out as the paper dries.

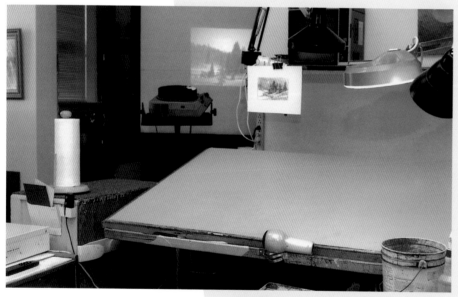

My Studio
This is a view of part of my studio. My slide projector is just on the other side of the table and the screen in the other part of the studio. I project the slide onto my paper and create a sketch, which I clip above my painting table as shown here. Then I use the drawing to make the painting.

Paints

Don't save money by using the cheaper, student-grade paints. If it is worth learning, it is worth learning on good materials. There are many brands of excellent quality, but since I love transparent colors, I have really fallen in love with the Quinacridone colors first introduced by Daniel Smith. These colors are vibrant, very transparent and flow beautifully in a wash.

Quinacridone Sienna, for example, is much more transparent and richer than traditional Burnt Sienna. Most of my paints are Daniel Smith, but I also use Winsor & Newton and Holbein brands. Try different brands and colors to discover your own favorites.

Brushes

Generally, flats and large rounds are used to cover large areas with paint, and small rounds are used for smaller areas and details. My requirements for these brushes are: (1) Rounds must come to a fine point and have a full body that's able to hold plenty of water, and (2) Flats must be thick enough at the ferrule to hold plenty of water. I don't want to run out of water three inches into a stroke. The flats must also come to a chisel edge when wet.

It used to be that the only choice was pure red sable—not anymore. Certain synthetic brushes and hair-synthetic blends are just as good for my money and have the advantage of being inexpensive. A few brands of rounds that I particularly like are Dick Blick 2047 series, Utrecht sablette 220 series and the Langnickel Royal Knight 7250 series. When the tip wears out, and they do about as quickly as a sable tip does, you can give them to the grandkids to play with and have no heartburn from it.

Other Materials

I sketch most with a 4B or 6B graphite pencil. I like the dark values I can get without pressing into the paper and leaving an indent on the next page. I also use these to draw on the watercolor paper. I can leave a line dark enough to be seen after the initial wash covers it, and it is easy to erase after the painting is finished because it is not imbedded in the paper.

The other supplies you will need to complete the projects in this book are: a hair dryer, palette knife, spray bottle, paper towels sketchbook and masking tape.

Quinacridone Gold

Aureolin Yellow

Cadmium Yellow Light

Raw Sienna

Brown Madder

Quinacridone Burnt Orange

Quinacridone Sienna

Cadmium Red Light

Quinacridone Rose

Alizarin Crimson

Quinacridone Magenta

Carbazole Violet

Manganese Blue

Ultramarine Blue

Sap Green

Viridian

My Color Palette

This is my current palette. I have them arranged in this order on my John Pike palette. You will notice that it is a little heavier on the yellows and reds, and lighter on the blues and greens. This is partly because I don't like most of the tube greens, preferring to mix my own, and partly because I respond to warm colors more.

My Brushes

This photo shows the brushes I use most: two large rounds (nos. 12 and 14), two small rounds (nos. 8 and 6) and a range of flats, from 2-inch (51mm) to half-inch (12mm). Like all artists, I have a lot more, but I have them primarily to make me look like an artist.

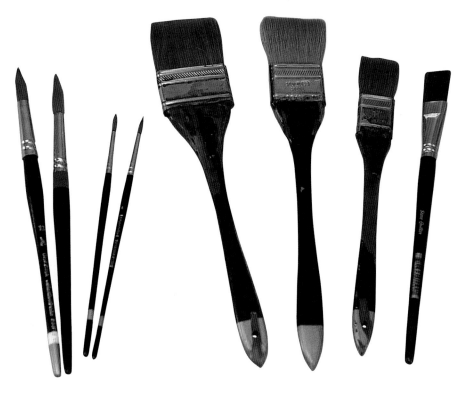

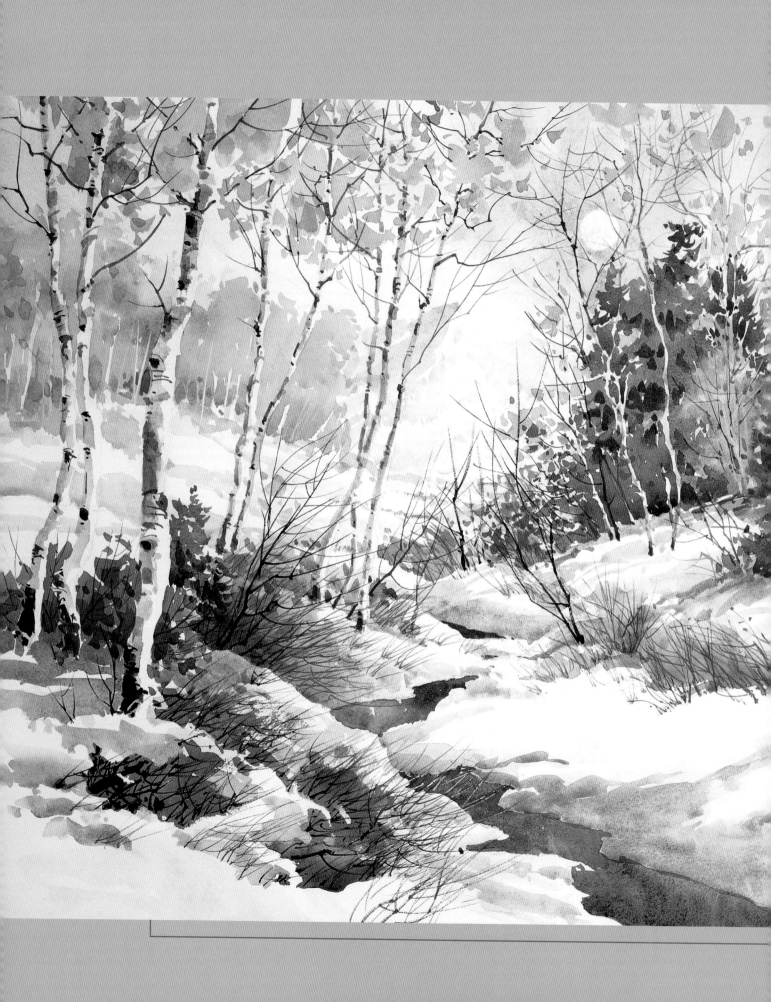

developing GOOD TECHNIQUE

Good technique is essential for painting fine watercolors. Technique may be more important in watercolor than in any other medium, because part of watercolor's charm and freshness relies on allowing the paint and water to do what they do so well, with a little guidance from us. This collaborative effort between the artist and the medium is at the heart of good watercolor techniques.

Look at one of your paintings and choose your favorite area: the spot you wish the rest of the painting looked like. Now choose the area you feel is least successful. Chances are you labored the longest in the least successful spot and painted that wonderful area in one quick shot. What follows in this chapter are some basic techniques that are essential for obtaining freshness of color and application every time. These techniques will help you get the most out of your paint and brushes.

As important as good technique is, however, know that good technique can never overcome the problems of a bad composition, whereas a powerful composition can overcome certain weaknesses in technique.

LAST OF AUTUMN ▸ Watercolor ▸ 28" × 30" (71cm × 76cm)

Mastering the graded wash

The graded wash creates a soft transition of color and can be used in many different ways. Mastering this and the other washes eliminates the frustration beginners experience during the painting process. Washes also are the key to the fresh, sparkling quality we admire in good watercolors.

Getting Started

Before applying any wash, moisten your paints. Saturated paints are essential to good painting. Dry paint results in washed-out, anemic-looking watercolor paintings. Squeeze out plenty of paint onto your palette. (Don't be conservative!) Be sure to keep the paints wet during the entire process of painting. Brushes wear out quicker when scrubbing them on dry paint in an attempt to pick up enough color for a painting.

When painting, match the brush to the shape. For a large shape, use a large brush. If the edge of the shape is intricate or otherwise impossible to paint with a flat brush, use a round brush. My rule of thumb is to use the biggest brush possible for as long as possible. If a shape can be painted with one stroke, it will always look better. Too many strokes ruin the shape.

To practice the washes on the following pages, divide a half sheet of watercolor paper into thirds with 1-inch (25mm) masking tape. In the first third draw a rectangle approximately ten inches (25cm) high and six inches (15cm) wide. In the middle section draw an abstract shape roughly the same size as the first rectangle. In the last section draw another rectangle like the first, but within the rectangle draw a few shapes or block letters.

Mix a middle-value color wash on your palette. In this example I used Quinacridone Sienna and water. Mix enough to cover the entire area of the first rectangle. This is essential. If you have to stop to mix more color, you will never get the same mixture and the previous stroke may begin to dry.

Begin the Wash

Tilt the painting support at a 15-degree angle, and prop something under it to keep it steady. Too much slant will cause the pigment to settle at the bottom of the bead of paint, resulting in stripes. If the board lies too flat, the water will not pull the pigment down the sheet. Fully load a round brush and pull a stroke of color across the top of the first rectangle. Hold the brush at a slight angle to the surface of the paper—not perpendicular. You must have enough water in the brush to form a bead at the bottom of the stroke as shown.

Pull Down the Bead

Quickly reload the brush with the wash. Touch into the bead and pull down another stroke across the rectangle, right below the first stroke. Resist any urge to go back into the first stroke. You cannot make it better no matter what you do, you will only make it worse. Just pick up the bead and carry it down. If a fleck of white paper shows up, leave it alone. No matter what problem seems to be there, do not paint back into the stroke.

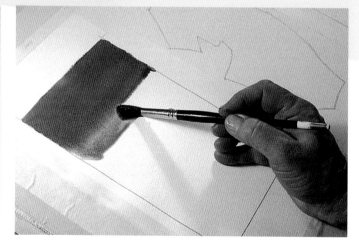

Add Water to the Wash

Dip the brush into clean water. Do not rinse it out, just add water to the color left in the brush. Pull another stroke into the bead of the last stroke and continue pulling the bead across. Continue down the page, adding more clean water to the brush after each stroke to gradually lighten the value. The last stroke should be clear water only.

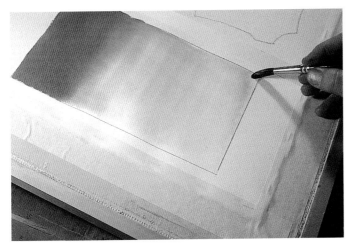

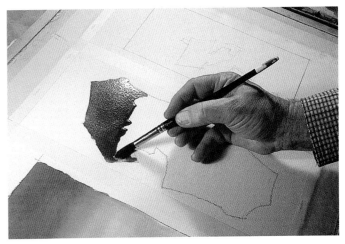

Pick Up the Final Bead

Lift the final bead of water at the bottom with a thirsty brush. Create a thirsty brush by rinsing it in clean water and squeezing it lightly with a paper towel. Then touch the thirsty brush into the bead of water. This will prevent backruns, where unnoticed little puddles of water at the edge of the paper may creep back into the drying wash. Keep the board tilted at the 15-degree angle until the wash is dry. Use a hair dryer to dry it faster. I find it useful to dry washes with a hair dryer. This speeds the drying and prevents backruns from occurring.

Paint a Graded Wash Within a Shape

Try the same procedure with the abstract shape you drew in the middle of your paper. Confine the strokes to the area contained within the shape. You can use this technique for smaller areas within a painting, such as mountains, water or wherever you need a gentle transition of color. Remember, just pick up the bead at the bottom of the previous stroke without painting back into that stroke.

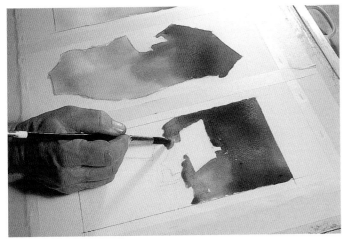

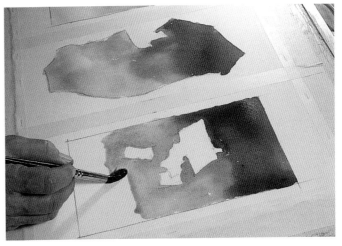

Paint a Wash Around a Shape

In the third section of the paper, pull a graded wash down the rectangle, but leave the shapes you sketched within the rectangle unpainted. Keep several beads progressing simultaneously until they join below the shapes. Keep practicing painting around these shapes until you feel comfortable doing them. This skill will come in handy in almost every painting you do—for painting around buildings, figures and so on.

Progress to the Bottom

Join the beads again and continue painting to the bottom of the rectangle. Remove the final bead with a thirsty brush.

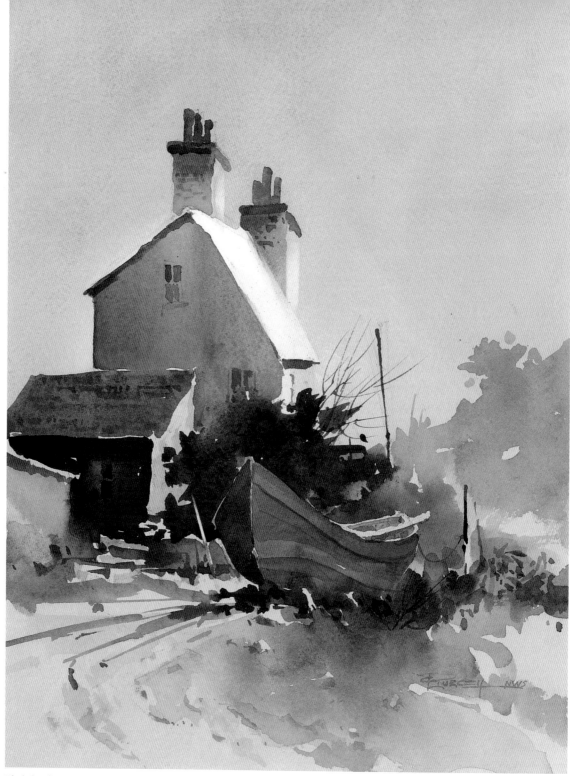

Finished Painting

This study of a house in Clovelley, Devonshire, England, utilized a graded wash of Quinacridone Gold in the sky, leaving the white rooftop and right edges of the chimneys. A graded wash of Manganese Blue was also pulled from left to right in the sky. Two graded washes, one of Manganese Blue and one of Quinacridone Rose and Quinacridone Sienna, were also used for the side of the building and the boat. Small graded washes of Quinacridone Sienna and Manganese Blue define the chimneys. The foreground is a mingled wash of Manganese Blue, Quinacridone Rose and Sap Green. These washes add vitality to the scene.

MORNING IN CLOVELLEY ▸ Watercolor ▸ 14" × 10" (36cm × 25cm)

No other medium is as adaptable to producing a gradual transition in color as is watercolor. It would take hours of tedious and careful brushing in oils to produce the gradual transition you will create as you do the following exercises. This is sometimes called a glaze, but it is simply a graded wash on top of a dried previous wash.

Graded washes also can be painted wet-into-wet. Wet the paper with clean water, either with a brush or a spray bottle. Pull in the first graded wash as described below, then immediately invert the board and lay down the second wash; however, the first wash must be completely wet. If it has started to dry, it will create a disaster.

There are only two times you can successfully work into a previously laid color: when it is still very wet, or when it is completely dry. When it is damp, leave it alone. Most muddy colors result from working into this stage.

Layering graded washes

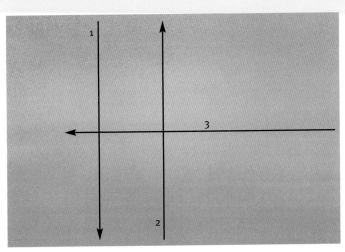

Build Layers of Graded Washes

Paint a graded wash on a quarter sheet of paper using Quinacridone Rose. After this has dried, turn the paper upside down and paint another graded wash using Ultramarine Blue. Complete the wash all the way to the bottom; do not stop partway. You should end up with nearly clean water at the bottom. After this has dried, pull another graded wash of Quinacridone Sienna from one side to the other.

1 Ultramarine Blue
2 Quinacridone Rose
3 Quinacridone Sienna

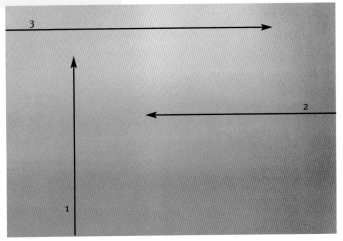

Try Another Variation Using the Same Colors

This time we will change the directions of the washes. Begin with the Quinacridone Rose in a graded wash from bottom to top. Next, pull a wash of Ultramarine Blue from right to left, and then one of Quinacridone Sienna from left to right. Notice that the Ultramarine Blue doesn't stain the Quinacridone Rose in the lower right, but allows it to visually mix with the blue.

1 Quinacridone Rose
2 Ultramarine Blue
3 Quinacridone Sienna

A Word About Pigments

Pigments range from quite opaque (Yellow Ochre, Naples Yellow, Burnt Sienna and Cerulean Blue) to very transparent (Alizarin Crimson, Quinacridone Rose, Phthalo Blue and Viridian). A few colors are termed staining colors because they sink into the paper and stain it rather than create a thin layer on top of the paper. Among these staining colors are Alizarin Crimson, Phthalo Blue, Phthalo Green, Prussian Blue and Carbazole Violet. Because they stain the colors underneath them as well as the paper, it is usually wise to use them in the initial washes and use the more opaque colors on top. Used in thin washes, these more opaque colors create a thin veil of color that allows the color underneath to peek through.

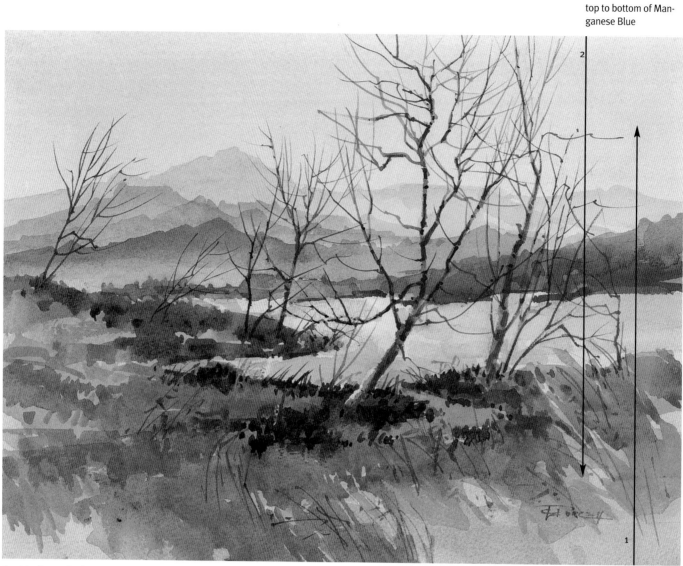

2. Graded wash from top to bottom of Manganese Blue

1. Graded wash from bottom to top of Quinacridone Sienna

An Underpainting Sets the Tone

The underlying wash (or underpainting) of Quinacridone Sienna provides a warm glow to all the subsequently applied colors. This could not be attained in any other way. Note how it warms all the land area. The graded washes in the mountain ranges give a hazy appearance to the distance and provide atmospheric perspective.

EVENING CALM ▸ Watercolor ▸ 10" × 14" (25cm × 36cm)

Replace those overworked areas with rich washes of mingled color and add richness and vitality to your paintings. Mingled washes are based on a visual reality that is overlooked because our intellectual brain gets involved.

In an effort to simplify the wealth of visual information it receives minute-by-minute throughout the day, the intellectual brain wants to simplify color. It sees the gradation of color in the sky from deep cobalt blue above us to warm green at the horizon and says, "blue sky." It labels a field as "green grass" even though it may have eight different greens, plus sienna and purple colors mingled throughout. It is rather Tarzan-like in its short reduction of facts: "tree green," or "house white." If we follow this lead, we fall into what I call the one-item-one-color syndrome.

When we really look, we will see a myriad of colors present in almost everything. Mingled washes are a way of bringing out that aspect by overstating it just a bit. Pablo Picasso said that the artist tells a lie to get at the truth. This kind of lie is okay to tell. It helps people see the beauty in the world around them.

Getting Started

On a quarter sheet of paper draw a vertical rectangle, and in the remaining space, two abstract shapes: one, a good shape for tree foliage, and the other a shape for ground. Then mix several puddles of warm and cool colors, all about midvalue.

Create excitement with mingled washes

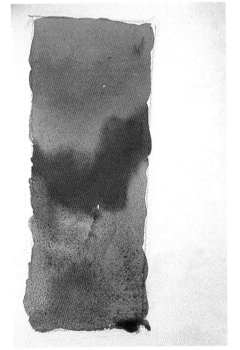

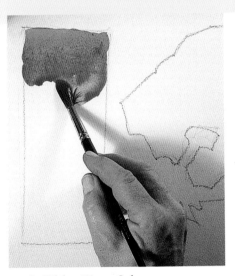

Begin With a Warm Color
Angle the painting support to about 15 degrees. Begin painting with one of the warm colors at the top of the rectangle. Give this stripe a varied edge. Use enough water in the mix to produce a bead of color along the bottom of the painted area. If you don't have a bead, you will only get hard edges between colors.

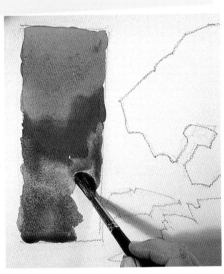

Mingle Different Colors
Rinse the brush and load it with another color. With the brush at an angle to the paper, and with the tip pointing up into the bead, pick up the bead and carry it downward. Every time you recharge the brush, do so with a different color: first use the warm colors, then the cool greens and blues.

When you reach the bottom, remove the water from your brush with a paper towel. Pick up the final bead by touching the thirsty brush into the bead of water; otherwise, it will run back up into the last color.

Finished Wash
Practice this with all the colors on your palette. You will find that some colors travel more slowly into the succeeding color, while others virtually explode into other colors.

Paint a Mingled Wash Within a Shape

Now let's try this wash in different shapes. This time as we paint each area, we also will focus on varying the edge of the shape so that it has both varied color and varied edges. This will be very important when you apply this technique to trees and other shapes in your paintings.

Continue onto the next shape. As you apply the first color along the top, angle the brush horizontally to the surface and drag it along quickly to produce a ragged edge. Point the tip of the brush into the shape so the edge is created with the heel of the brush. If the brush is pressed down nearly to the ferrule, the heel of the brush will produce a more ragged edge than the tip. Then add more color and increase the area of color. Remember to use enough water to produce a bead.

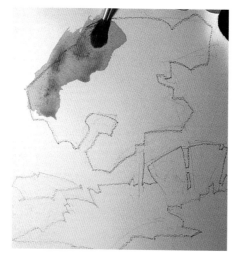

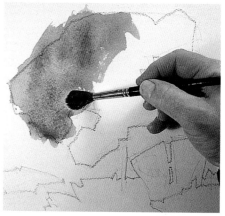

Mingle a New Color

With a fully loaded brush of a different cool color, pull the bead down into the shape.

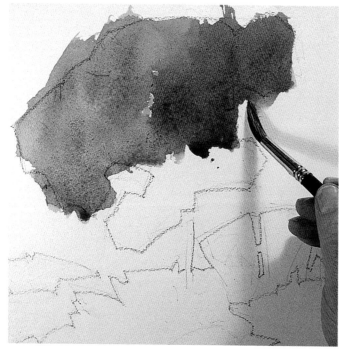

Soften the Edges

Before the wash has a chance to dry, use a damp brush to soften edges here and there, creating eye-pleasing variation. Don't take too long or the bead will dry. If the bead dries, you will get a hard edge that will be much more difficult to soften without scrubbing it into submission. Grab the bead with a new color and continue.

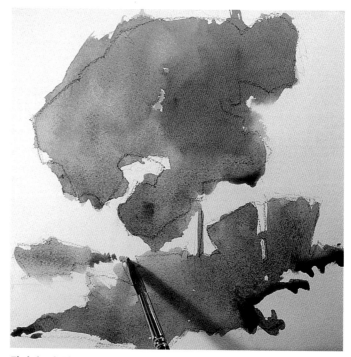

Finished Shape

You now have an interesting shape painted with exciting colors and a variety of edges.

Do the same with the shape below it, this time using more greens and yellows. I prefer mixed greens to tube greens as they look more natural. Some of my favorite mixtures are Manganese Blue and Quinacridone Gold, Ultramarine Blue and Quinacridone Sienna, and Manganese Blue and Quinacridone Sienna.

To create a tree with foreground grasses and a fence, add a few calligraphic details on top of the last mingled wash.

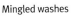
Mingled washes

Pale graded wash of Quinacridone Sienna and a touch of Carbazole Violet

Breaking Free From the One-Item-One Color Syndrome

In this painting you can see how mingled washes enhance the trees, ground and foreground areas. Using mingled washes will free you from the one-item-one-color syndrome. The warm foreground wash of Quinacridone Sienna helps create a sense of distance, since warm colors appear to advance and cool colors appear to recede. It also gives this scene a warm autumn glow.

AUTUMN PASSAGE ▸ Watercolor ▸ 11" × 14" (28cm × 36cm)

Getting the most out of your brushes

The two basic watercolor brushes, the pointed round and the flat, are designed especially for watercolor. Too often they are treated as mere paint applicators. They should be thought of as specialized tools designed to produce the best possible effects. When used correctly, they will serve you wonderfully.

A good watercolor round brush holds a lot of water and is versatile in that you can paint with the body of the bristles or use the tip for fine lines. A flat brush has more versatility than one would think, but it can also cover large areas of paper quickly, with fewer strokes. Practice these strokes to see what your brushes can do.

Loading a Brush
Using a no. 6 or no. 8 round, mix a puddle of rich, dark color on your palette. The consistency should be fluid but with plenty of pigment. Then load the brush. As you pull it away from the edge of the puddle, twist the brush handle between your thumb and forefinger as you lift up. This aligns the hairs to give you the best tip.

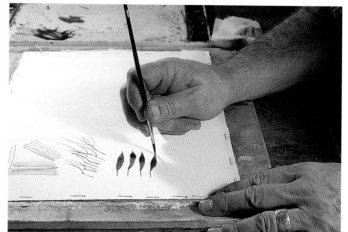

The Controlled Line
Hold the brush as shown, perpendicular to the surface of the paper. Only a vertical position gives you control at the tip. Do not hold the brush at an angle like you do a pen when writing. Let the heel of your hand rest on the paper. This position gives you vertical stability and control of the pressure at the tip.

Lock the wrist and fingers in this position. Use your arm to move the brush, not your fingers or wrist. Paint a series of straight lines, both horizontal and vertical. Practice until you can consistently pull lines of the same width. Watch your hand as you do this. Don't allow your fingers or wrist to move.

Now try some combinations of diagonal and curved lines, similar to what you will find in trees. A slanting position to the brush will not allow you to control the width of the curved lines, so maintain a perpendicular position for the brush at all times.

Paint Lines of Varied Width
By practicing proper brush position, you control whether the stroke will be thin or thick. Hold the brush the same way as before, but as you begin the line press the brush straight down into the paper while continuing the stroke. As you pull the stroke, twist the brush handle between thumb and forefinger as you pull the brush up to the starting position. Maintain the vertical position throughout. Practice these strokes to gain control and mastery of the brush.

Consider taking a brush calligraphy class; this is a great way to learn brush control.

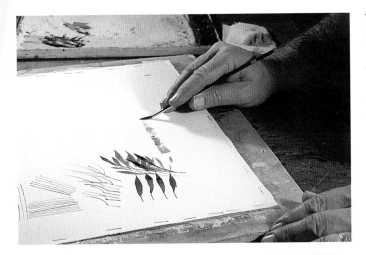

The Side-Drag Stroke

Load a no. 10 or no. 12 round with juicy color (plenty of pigment and water). This time we will lay the brush down and drag it sideways instead of using the tip. Point the tip away from you and hold the brush almost horizontal to the surface. Drag the brush sideways. Vary the line lengths. Drag, then lift and skip a little space. This lifting will leave some lights.

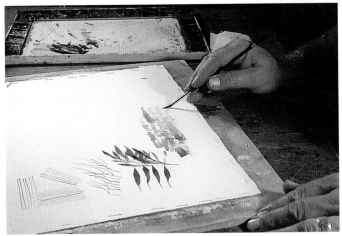

A Broken Wash

Drag another stroke along the bottom of the previous line. Each time you recharge the brush with color, vary the color. This produces a kind of broken wash, which is great for grasses and foreground texture. Stagger the lights so they don't line up vertically.

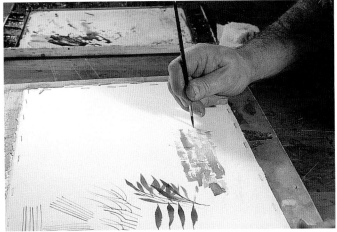

See the Possibilities

Adding a few lines here and there with the tip of your round will complete this textural foreground.

The Stab

Load a brush with color and, holding it vertically to the paper, press the brush down to the ferrule and then lift off. Try twisting it as you lift off. This will produce a different mark every time, and can be turned into chickens or used in foliage or for any number of other possibilities your imagination can create.

Spattering

Load a brush with color. Hold the brush over the paper and tap it with your other hand. This distributes droplets of paint over the paper.

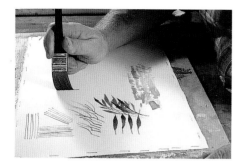

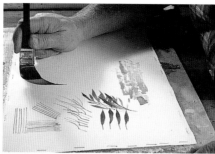

Paint a Thin Line

Load a 1-inch (25mm) flat brush with color and hold it vertically above the paper. With the long edge pointing away from you, begin painting a thin stroke away from you. A good flat brush can produce a fairly thin line.

Continue With a Wide Stroke

As you push the line up, lean the brush over and push down on the bristles without changing the brush position in your hand. This produces the widest stroke possible.

Finish the Stroke

Finish the stroke by twisting the brush slightly and lifting up, with the far edge of the chisel leaving the surface last.

Try a Variation of the Previous Stroke

Begin with the brush in the same position, but this time pull the stroke toward you. As you do, begin twisting the brush while pushing it down into the paper.

Finish the Stroke

Lift the brush as you twist it. Finish the stroke with just the corner tip of the brush. This stroke is useful in a number of applications, especially for building the planes in rock formations.

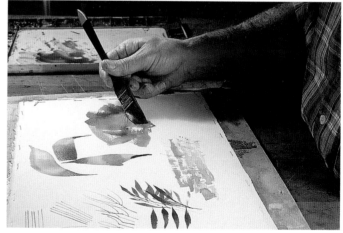

The Side-Drag Stroke

When you drag a flat brush sideways, you will find that the hairs splay out and produce some accidental edges—wonderful for foliage. Press the brush down all the way to the ferrule and quickly drag it sideways, pressing the corner of the brush into the paper, not the flat edge.

Ragged Edge

Notice that the most ragged edge of the stroke is made by the part of the brush at the ferrule end, not the tip end.

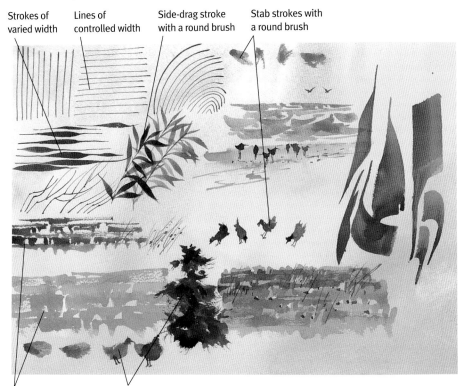

Strokes of varied width

Lines of controlled width

Side-drag stroke with a round brush

Stab strokes with a round brush

Strokes of varied width using a flat brush

Side-drag stroke with a flat brush; calligraphy strokes added

Make a Practice Sheet

Making practice sheets like this one will help you see the possibilities with each brush. Build your paintings with a combination of basic washes and carefully placed strokes. Use these strokes to suggest or reveal "things" as you bring a stroke around a shape. Don't approach the process as an exercise in painting things or you will end up simply coloring between the lines.

A Painting Built on Washes and Brushwork

Here is an example of a painting done completely with basic washes and applied strokes. Can you identify the different strokes?

SANDSTONE BUTTE
Watercolor
$10\frac{1}{2}" \times 14"$
(27cm × 36cm)

Mingled wash of Quinacridone Gold and Quinacridone Sienna; patches of Manganese Blue added to the wash in the bottom area

Strokes of varied width using a 1-inch (25mm) flat and a mixture of Quinacridone Burnt Orange and Carbazole Violet

Side-drag strokes with a no. 12 round

Calligraphic lines with a no. 8 round

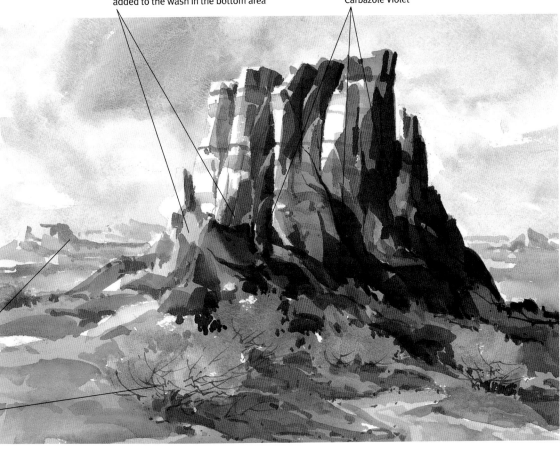

Create a painting using
WASHES AND STROKES

In this demonstration you will practice beginning a painting with graded washes, then building forms using some of the brushstrokes described on the previous pages.

materials

PAPER
Arches 140-lb.
(300gsm) rough

BRUSHES
Nos. 8 and 12 rounds
½-inch (12mm),
1-inch (25mm) and
2-inch (51mm) flats

WATERCOLORS
Burnt Sienna
Carbazole Violet
Manganese Blue
Quinacridone
Burnt Orange
Quinacridone Gold
Quinacridone Rose
Quinacridone Sienna
Sap Green

OTHER
6B pencil
Hair dryer
Palette knife
Spray bottle

WATERCOLOR DEMONSTRATION

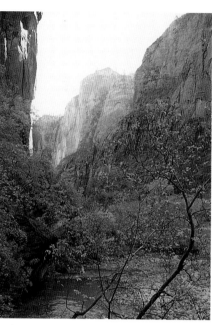

Reference Photo
This photo was taken in Zion Canyon in southern Utah. The walls of the canyon rise vertically here, nearly two thousand feet from the canyon floor.

Create each shadow plane with a single stroke by twisting the brush.

Fade out edge of the wash where later forms will overlap it.

1 Start With a Graded Wash and the Shadow Planes of the Mountains

After creating the drawing, slightly tilt the paper, spray it with clean water, and paint a graded wash of Quinacridone Rose and Carbazole Violet using a 2-inch (51mm) flat. While this wash is still very wet, turn it upside down and paint a graded wash of Quinacridone Gold. Speed dry it with a hair dryer. This is the foundation for the painting.

Begin building the mountain forms by laying down single strokes using a 1-inch (25mm) flat and a light combination of Manganese Blue and Quinacridone Rose. Twist the brush to vary its width as you pull each stroke down. By painting strokes that describe the shadow planes, you automatically create the light planes.

For the closer forms use a darker version of these colors warmed up with some Quinacridone Sienna. Soften the edge at the bottom with a thirsty brush; you don't want a hard edge where the foreground trees are going to be. If I am unsure how I want a passage to end, I "fuzz it out" so it won't dry with a hard edge, leaving me with more options.

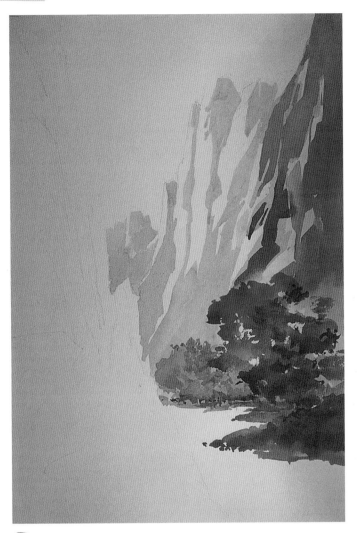

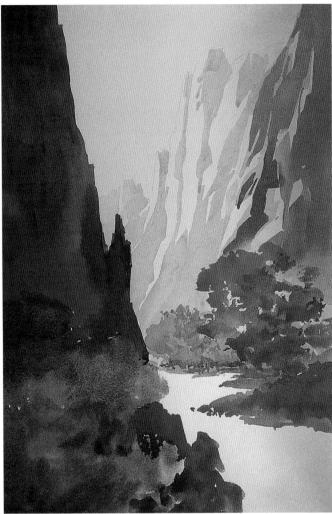

2 Create the Foliage With Mingled Washes
Begin the foliage in the middle ground by applying Quinacridone Gold on the left. Add some Manganese Blue as you recharge your brush. While that is still wet, begin at the top of the closer trees with Quinacridone Sienna, and add a little Sap Green as you move downward. Mingle the wash with Carbazole Violet as you bring it down into the riverbank.

3 Add the Dark Foreground Mass
Don't simply color in between the lines for the rocks and bushes. Stay visually focused and think of this as one large shape created with a mingled wash. Begin at the top with a dark mixture of Quinacridone Sienna and Carbazole Violet. Every time you reload the brush, vary the color a little with Quinacridone Sienna and Manganese Blue.

Don't let the wash dry when you reach the bushes. Immediately charge it with Manganese Blue and Quinacridone Gold, then Carbazole Violet at the bottom. Include Quinacridone Sienna where some of the rocks might show through the foliage. Finish painting the rock forms with the Quinacridone Sienna and Carbazole Violet mixture.

4 Start Defining the Forms

Calligraphic strokes define the forms. There are two kinds of details: one enhances and explains the structure of the forms; the other is decorative, which only embellishes or decorates surfaces. Go for the former kind first—you may not need any of the latter. Scratch a few branches into the moist paint with a palette knife.

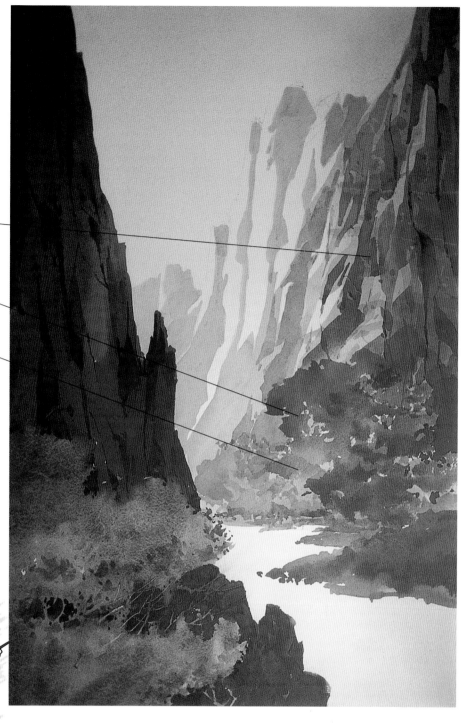

Define the forms with a ¹/₂-inch (12mm) flat. Make this wash a little darker than the initial wash. Vary the width.

Bring down some dark colors and carve out the lights of the foliage.

Create branches by darkening the spaces between and around the branches.

Keep Your Strokes Few and Simple

Watercolor is like golf—the fewer strokes, the better the game. Every time you go back over a previous brushstroke, you weaken its power.

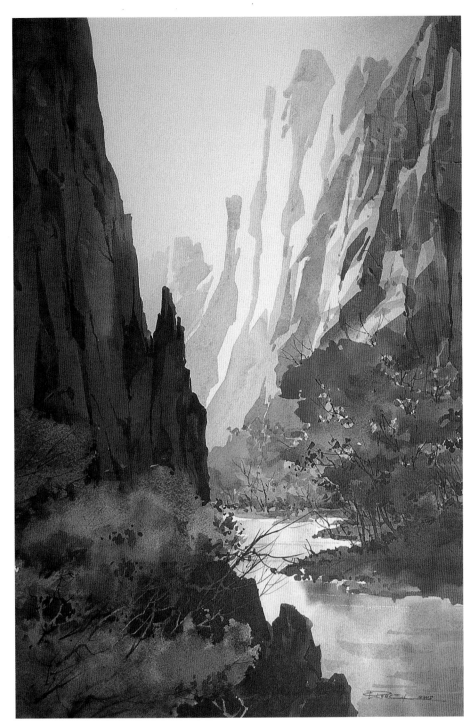

Add Final Details

With a no. 8 round and a mixture of Carbazole Violet and Quinacridone Burnt Orange, add a little more calligraphy for the tree branches and bushes. Wet the river area with clear water and drop in the colors from above, reflecting the trees and rock forms. When this is dry, paint a few horizontal strokes of Carbazole Violet and Quinacridone Rose with a no. 12 round to suggest movement in the water.

After finishing the painting, I decided that the bushes in the foreground were a little too cold and needed some of the autumn warmth found in the distant trees. I wet the area with clean water, and with a clean, damp sponge, wiped out some of the blue-green. While the area was wet, I dropped in some Quinacridone Sienna to warm up the corner. I added a few calligraphic lines to finish it off.

AT THE BOTTOM OF THE CANYON
Watercolor
21" × 14" (53cm × 36cm)

POINTS TO REMEMBER ☞

- ▸ Good technique may be more important in watercolor than in any other medium.

- ▸ Gain a powerful tool by mastering graded and mingled washes.

- ▸ Use plenty of water and paint. The purpose of painting is not paint conservation.

- ▸ Look around and you will see mingled color in everything. Nothing is one color only.

- ▸ To create calligraphic lines, keep the brush perpendicular to the surface and propel it with your arm, not your fingers.

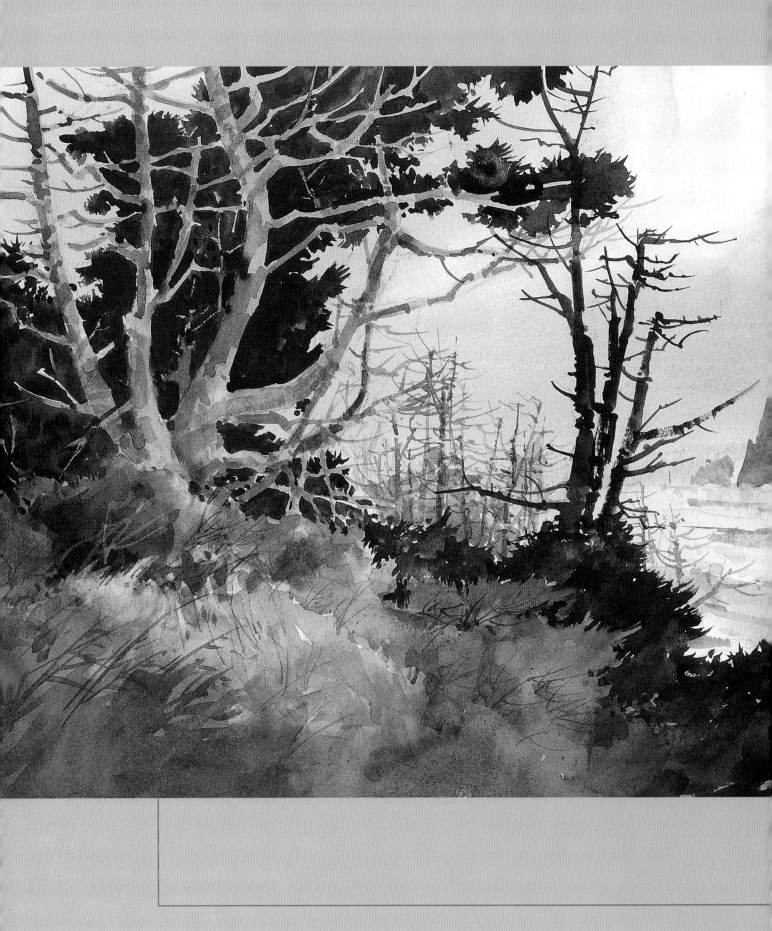

the TWO BRAINS

The human brain is incredibly complex, but for our purposes we may say that each person has two brains—one visual and one intellectual. The visual brain sees and records shapes and positions in space, while the intellectual brain identifies and interprets information. This is a simple way to explain the two basic methods our brains have for processing all the visual information that comes in through our eyes. Using the wrong brain in the painting process can be like trying to use a hammer to put a screw in a wall.

OREGON COAST LIGHT ▸ Watercolor ▸ 14" × 21" (36cm × 53cm)

Know your visual and intellectual brains

Let's take a closer look at the functions of the visual and intellectual brains.

The Visual Brain

This part of your brain records shapes and patterns of color and value, along with the spaces around them. It works extremely fast at providing you with the spatial information you need to navigate through space and around objects. It operates just below your conscious level.

The Intellectual Brain

This part of your brain assigns names to the shapes and patterns sent from your visual brain, and creates links to previously stored information. It directs most of your conscious activities and simplifies the vast amount of information it receives to prevent information overload. It does this through generalizing and categorizing the information and creating very simple symbols that stand for—but don't closely resemble—the complex shapes your visual brain sees.

When you see a tree, your visual brain records its shape, location, value (lightness or darkness), texture and position in space relative to you and the other surrounding shapes. This information is then sent to the intellectual brain, where it is processed. The shape is identified as a tree, its type and so on. More information about the tree is added. For example, its foliage is made up of thousands of leaves.

The Enemy Within

It helps to understand these two functions of the brain and how they affect each other. To identify, categorize and name a tree you need the information stored in the intellectual brain. To paint a tree you need to consciously access the visual information first recorded by your visual brain. You need to see the actual shape of the tree, the value and color nuances of that shape, and its relationship to the shapes around it. You don't need the simplified symbol your intellectual brain stored when you were five years old. You don't need to know there are thousands of leaves on it, or that foliage is green and the trunk is brown. These generalities replace actual observation. This information actually prevents you from seeing.

This interference from the intellectual brain will be the greatest problem you will face in developing your artistic skills. This is your enemy within.

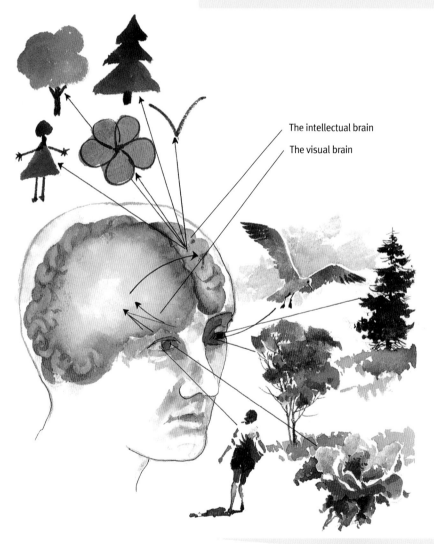

The intellectual brain

The visual brain

How Your Brain Processes What It Sees

Complex shapes enter the brain through the eyes and are simplified by the enemy within—your intellectual brain—into symbols that merely represent the original item. These symbols are recalled when you try to paint what you see. Additional information about these things is added to the perceived information. As a result, you may paint a person, animal or object as you think it should look instead of how it actually appears.

Your intellectual brain is useful for generating shopping lists, organizing meetings and balancing your checkbook, but not for creating art. To be a good artist, you need to rely on your visual brain, or artist's brain. Training your artist's brain is really a matter of bringing what it normally does on an unconscious level into conscious use.

Your visual brain helps you find a space on a shelf for the sugar, straighten a painting on a wall, walk between two objects without collision or catch a ball. These are spatial and visual tasks that do not require intellectualizing. You perform them with a bare minimum of conscious thought. As a painter, your artist's brain

thinks along the same lines: it sees how shapes fit together, compares the values of different colors and recognizes the position of an object relative to the objects around it.

Part of what makes creating realistic art so challenging is that it requires the capability to use the visual brain—your artist's brain—on the same conscious level that is usually reserved for intellectual thinking. No wonder the intellectual brain intervenes and tries to take control of the process! This is its territory. But if you let it interfere, it will proceed to ruin a painting. When it has made a disaster of your artwork, it will offer a critique: "You're just no good at art!"

Training your artist's brain

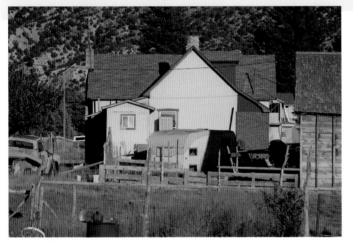

Your Visual Brain Recognizes Good Values, Not Good Objects

What do you first see in this photo? A house? No. The first thing you see is a white shape surrounded by dark, and then you identified the shape as a house. Then your intellectual brain started identifying the trailer, pickup truck, fence, shed and so on. Right away you are out of the visual mode and into the intellectual mode of separating and identifying.

What Makes the Scene a Good Possibility for a Painting?

Look at this version in which the white shape is gray. Pretty boring, isn't it? The aspect that got our attention in the original photo was the white shape surrounded by dark, not the fact that the shape was a house. If we want to create strong paintings with visual interest, we need to focus on this kind of visual information.

Think Visually

In this sketch I have kept the idea of a light shape set against a dark background, but I've included a pathway of light leading to the house. Notice that my camera didn't think to do this. It's not smart enough!

The barrel and the bike in the foreground of the photo did not make it into the drawing because the visual brain does not busy itself collecting useless items that do not contribute to the larger shapes. Your visual brain—your artist's brain—doesn't record items such as the fence as an actual fence. It records it instead as part of a larger shape of similar value. In my drawing, I connected the fence to the light foreground shape.

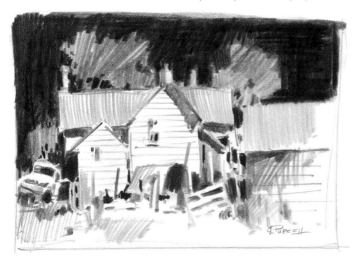

Intellectual symbols vs. visual symbols

A symbol is a visual method of expressing a complex concept or involved body of information. Our brains are capable of creating two different types of symbols. It does this for two different reasons:

1. The intellectual brain, the enemy within, takes a complex concept or mass of information and creates a simple package for it. When it creates a symbol for a pine tree, the symbol is intended to represent all pine trees, not resemble a specific one.

2. The visual brain, the artist's brain, creates a symbol for a pine tree based on careful observation of the shape. Its symbol preserves the complexities of the shape and is intended to resemble a specific pine tree, not merely represent one.

If we as artists want our paintings to have any semblance of reality, we need to create visual symbols based on the serious observation of nature and avoid the quick-fix symbol the enemy within provides.

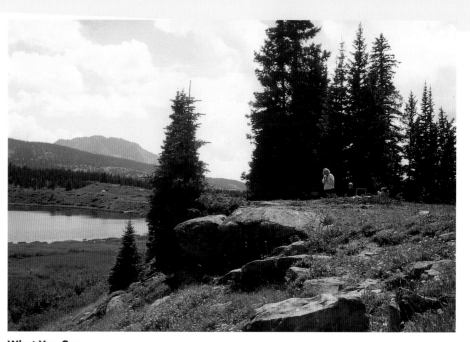

What You See
Here you see a pair of pine trees behind the rocks and a group of tall pines in the background.

The Symbol Your Intellectual Brain Creates

If the enemy within becomes involved in the art process, this is what happens: We see the tree as it appears in the reference photograph. We call it a pine tree, and immediately the enemy says, "I can help. Here's a pine tree image from my files." We can see, however, that the symbol looks nothing like the real thing, so we compromise and create a new symbol that combines aspects of what we see and what we know from our "files." The drawing that results (on the far left) is not interesting and will not intrigue the viewer.

The drawing next to it is one I created in the third grade. It clearly looks like a child's drawing, but it's not terribly unlike the perfect pine tree images stored up in my intellectual brain.

The Symbol Your Visual Brain Creates

If we really observe the shape of the tree—especially the complexities along the edge of the shape—and then improve the shape to make it more interesting, we might create a visually based symbol that looks like this.

Become visually articulate

To avoid having the enemy within distract you into considering every little detail of a subject, you need to be visually focused. This requires two practices:

1. Know the enemy within—your intellectual brain—and how it operates.

2. Become visually articulate.

One thing that would help shift your thinking from objects to shapes and other visual attributes is: Instead of attaching names to all the objects you see, begin describing them in visual terms only. Say things such as, "I like that light shape against the dark," or "Look at that orange shape surrounded by green," or "I like that pattern of light that leads back to the focal point."

If you consciously identify the visual aspects of your subject, there is a better chance you will respond to them in your drawing and painting. Here are some subjects to which I have given visual names, then responded to with drawings.

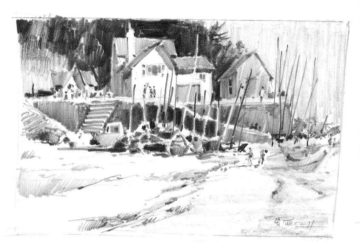

A light shape against dark with vertical lines

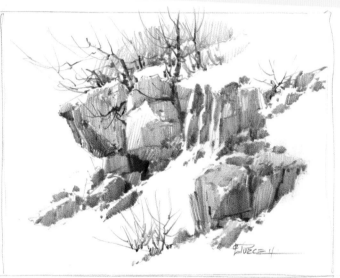

A dark shape against light

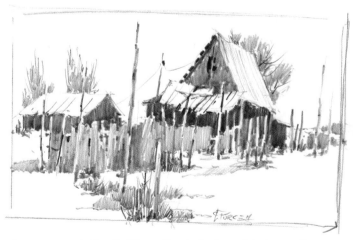

An arrangement of vertical lines offset by horizontal design motifs

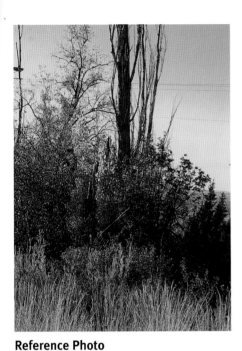

Reference Photo

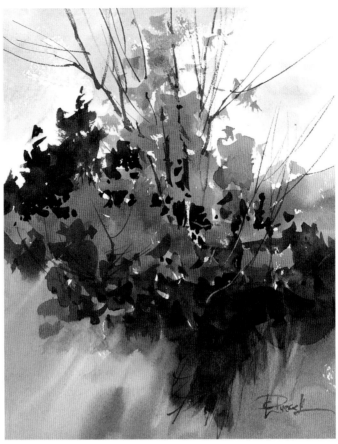

Connecting Shapes of Similar Color
Here is a shape of red sandwiched between two bands of dark green. Vertical lines cut across the bands. How can I connect the bands of dark and have them push into the bottom area?

Reference Photo

Contrasting Complementary Colors
Here we have a large shape of blue-green with a splash of yellow-orange within it. What a beautiful contrast of complementary colors! Placing the darkest darks next to the yellow-orange increases the contrast.

Responding to value contrast

Your ability to build a strong painting is bound tightly to your artist's brain, which will allow you to see shape and respond to visual stimuli rather than letting your preconceived notions of a subject take over your thinking. In the following example, I could have easily been caught up in portraying all of the details of this charming village, but instead I responded to the attractive value contrast in the scene.

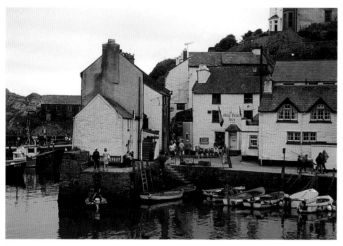

Reference Photo
Polperro in Cornwall, England, is a delightful little village. In this view I could have responded to the shapes, the linear patterns, the rhythm of the boats, the color or the texture. I chose the contrast of values. I liked the white shape of the house against the darks. If you want this white shape to show up, get rid of all the other whites.

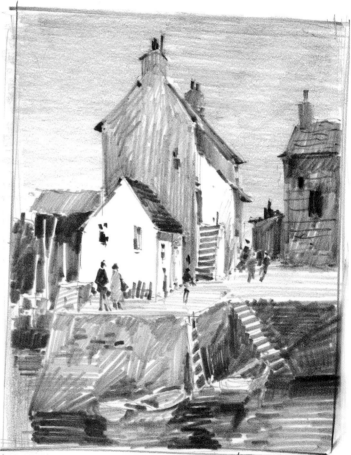

Value Sketch
Make a drawing in which the white shape is surrounded by values darker than it is. Use a 6B pencil so that you don't have to work so hard to get the darks. Place the darkest values next to the white shape and add smaller dark shapes in front of the white shape to bring more interest to the area. Place the figures to add interest, movement and a human element.

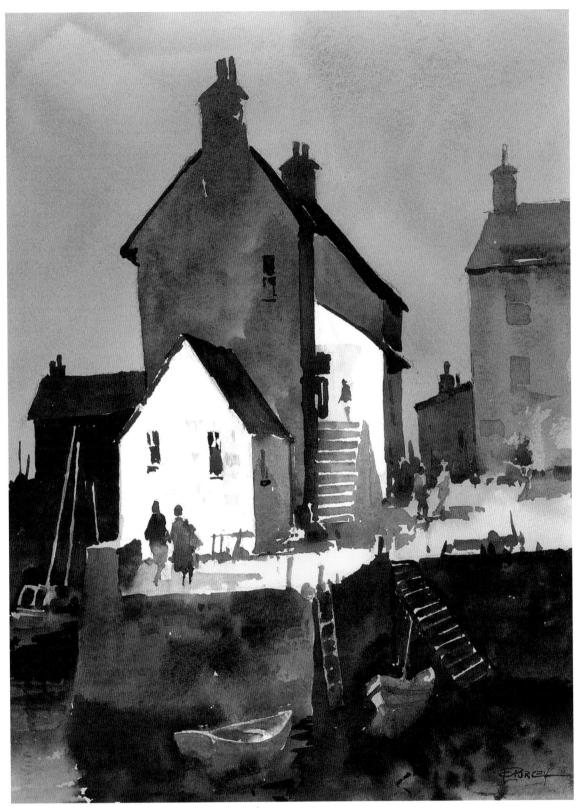

A Followed Plan and a Finished Painting

A painting is no better than its plan. When creating a painting about value contrast such as this, apply a wash of color over everything but the white shape. This ensures that nothing else will be as light, which is why the white house stands out. The more white eliminated, the more important the remaining white will be. Placing the darkest values next to the white emphasizes the lightest shape even more.

POLPERRO HARBOR ▸ Watercolor ▸ 15" × 11" (38cm × 28cm)

materials

PAPER

Arches 140-lb
(300gsm) rough

BRUSHES

Nos. 10, 12
and 14 rounds

2-inch (51mm) flat

WATERCOLORS

Carbazole Violet

Manganese Blue

Permanent Rose

Quinacridone
Burnt Orange

Quinacridone Sienna

OTHER

6B pencil

Sketchbook

Paper towels

I was never a colorist—an artist who bases art on color theories. I began my career emphasizing aspects of value. I guess I was a valueist. As I progressed as an artist, I realized that I used shapes of value to build my paintings, so I guess you could say I evolved into a shapeist!

Try this demo and experience how it feels to respond to a shape instead of objects, such as grass, weeds, fence posts and so on. Remember, a painting is built of shapes, not items.

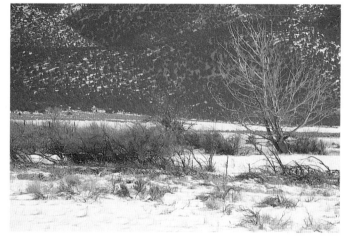

Reference Photo

When I photographed this scene I was not thinking, "I want a picture of those beautiful bushes and that lovely tree." Instead I thought, "That is a nice dark shape of reddish color those bushes form. It's kind of a 'C' that ends at the top with a diagonal movement in the tree." That's visual thinking.

Value Sketch

Draw the shape. Don't get sidetracked by all the details. See the bushes as a large shape, with variety in width and lots of interaction with the background. Don't give the enemy within a chance to count bushes or fence posts, just see and record what is important: the large, dark, irregular shape of the bushes against the light of the snow and sky.

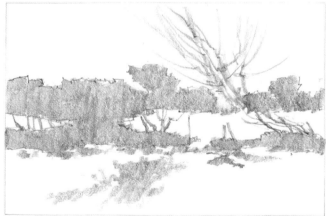

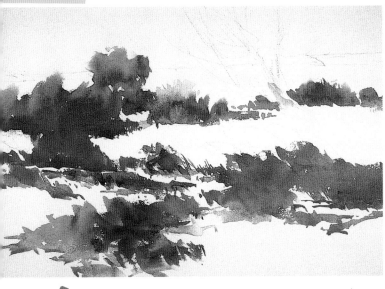
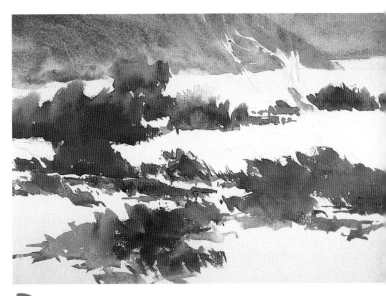

1 Establish the Dark Shape

Start by drawing the reddish bush shapes on the watercolor paper; think of them only as dark shapes. Then load a no. 12 or 14 round with Quinacridone Sienna, using plenty of water and pigment. Elevate the right side of the painting board. Beginning at the upper right end of the shape, lay the brush down with the tip pointing toward the top and drag the brush sideways, twisting and skipping it as you go to make an irregular stroke. Leave a few breaks in the shape for light tree trunks that you'll paint later.

After a few inches, pick up more water and some Carbazole Violet. Touch this into the previous stroke and continue. (Never go back into the previous stroke; just pick up the bead of paint and move on.) This allows the water to mingle the colors on the paper, producing a fresh color mixture. Always keep plenty of water in the mixture; you can't make a fluid and continuous wash if the brush is too dry.

Add a little Manganese Blue to the mixture, then some Quinacridone Burnt Orange as you move to the left side of the painting. Continue back along the bottom segment of the shape, dragging the brush sideways to produce an irregular edge. Paint a few shadows on the snow under the shape using Manganese Blue and a touch of Quinacridone Rose. Do this while the first color is still wet so the two will mingle.

2 Lay In the Background Shape

The gray background shape will make the remaining white appear more brilliant. With a 2-inch (51mm) flat, mix some Manganese Blue and Quinacridone Sienna. These will look ugly on the palette, but on paper they will separate and produce a layered gray. Pull the shape across from left to right, leaving a few light lines for the tree limbs. I prefer this method to masking them out with masking fluid. This way you get irregular patterns and don't have hard edges to deal with later.

Before the wash dries, touch the bottom edge with a wet brush in a few places to create some soft areas and add some variety. To make the more distant mountains on the right, simply pat that part of the wash with a paper towel before it dries. Notice how the jog in the bottom edge of the gray shape pushes that mountain back in space.

3 Continue the Snow Shadows

Mix Manganese Blue with a little Quinacridone Rose and continue the shadow patterns in the snow using a no. 12 round. Create natural-looking, irregular shapes instead of perfectly repetitious shapes by laying down the brush and dragging it sideways. These shadow shapes help emphasize the horizontal angle of the ground. Begin in the distance with narrow horizontal strokes and gradually make them wider and more undulating as you proceed toward the foreground. You now have the complete foundation for the painting, and with no details!

4 Add the Details

This step is what everyone wants to do first because the enemy within tries to convince us that the details are responsible for the way things look. This is not true. You can recognize someone you know from a distance without seeing any details just by their shape and gesture. Details don't build form; they only enhance the forms, like decorating a cake.

The details in this painting consist of calligraphic strokes and a few darks. Begin with the dark shadows on the bushes. Load a no. 10 or no. 12 round with a mixture of Quinacridone Burnt Orange and Carbazole Violet and drag it under the line of the bushes. Let the brush just skip along so the pattern is irregular. Touch the top edge with a wet brush in a few places to soften the edge.

Carbazole Violet and Quinacridone Burnt Orange will produce a good dark value for the calligraphic lines of the tree limbs and weeds. Hold the tip of the brush perpendicular to the painting surface when adding these lines. When you see dark limbs in nature, you will usually see light limbs too. You can add these in by painting them with clean water, then wiping up paint with a paper towel.

WINTER COLOR PATCH ▸ Watercolor ▸ 14" × 21" (36cm × 53cm)

POINTS TO REMEMBER ☞

- ▸ Your visual brain possesses the abilities you need to make art.
- ▸ Your intellectual brain can categorize and name items, but it is your enemy when you are trying to paint.
- ▸ The enemy simplifies visual information by creating a symbol—usually one with a boring shape.

- ▸ Train your visual brain to become conscious by thinking and speaking in visual terms of shape, color, line and so on.
- ▸ Respond to visual aspects of your subjects—what something actually looks like, not what you think it to be—as you paint.
- ▸ Lights and darks build forms; details decorate them.

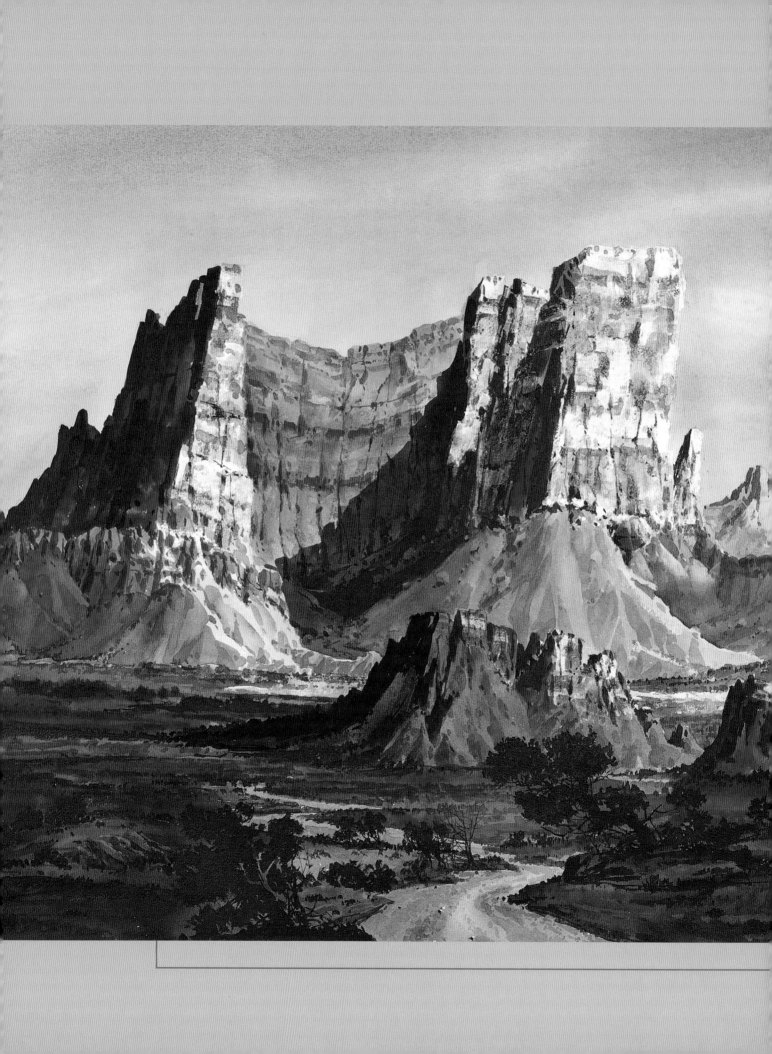

seeing SHAPES

Everything you paint is a shape. You cannot paint a tree; you can only paint a shape of color and value that conveys the visual information of a tree. You are working on a two-dimensional sheet of paper. A tree or any other object is a three-dimensional form in space. As soon as you represent that form on a flat surface, you have done so with a shape; therefore, it is critical for you as an artist to be able to see subjects as shapes.

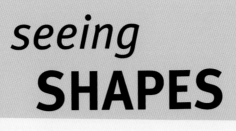

DESERT CATHEDRAL ▶ Watercolor ▶ 24" × 33" (61cm × 84cm)

Use silhouettes to find interesting shapes

To help you see the shape of any item, ask yourself, "If the object I am looking at were cut out of black paper, what would its silhouette look like?"

Seeing a form as a silhouetted shape allows you to discover if that shape is either visually interesting or boring. Visually interesting shapes entertain the eye. Visually boring shapes are static, uniform simplifications or generalizations of facts.

Most people can tell an interesting shape from a boring one. But, when we pick up a pencil or paint brush, a curious thing happens. If the shape we're looking at is boring, we paint it that way. We tend to want to paint the shape just as it is, without changing it to make it more interesting in our composition.

Looking at an object from several different points of view will help you find which view presents the most visually interesting shape, or silhouette.

Interesting Rock Forms

At the base of this beautiful waterfall is a collection of rocks. As forms the rocks are interesting, but that doesn't mean their overall shape is interesting. I liked the rocks as a visual element and their location, but notice what happens when you silhouette the shape.

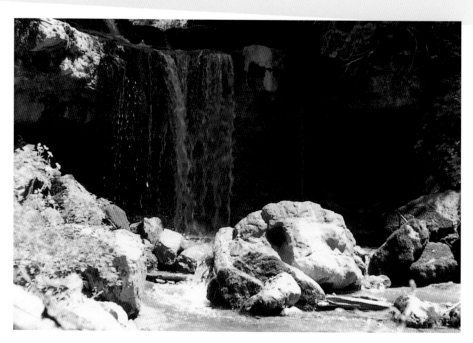

Uninteresting Rock Silhouette

This is what the shape would look like if you cut it out of black paper. I like the placement of these rocks, but their shape is unexciting—just slightly more interesting than that of a marshmallow. However, the silhouette could look very different and more interesting if the rocks are viewed from another angle.

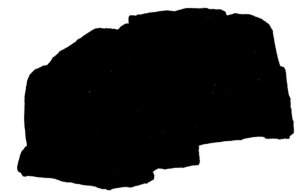

Sometimes you may see an interesting shape in nature but turn it into a boring one on paper. Even though you realize the attributes of the interesting shape, this does not deter the enemy within from affecting your ability to recreate the interesting shape. Let me illustrate why this happens.

How your brain can make an interesting shape boring

What You See

This tree is an interesting shape. There is some complexity and variety to it.

What Your Artist's Brain Records

Your eyes see the tree in the photo and then send it to your artist's brain, which records the shape just as it is. Then the image is sent to the intellectual brain for identification and naming.

What Your Intellectual Brain Produces

Here the image links with previously stored information, including other symbols for trees, and becomes simplified. All the visual complexity that makes the shape interesting is eliminated. A symbol is created to stand for the tree. It is not meant to look like the tree, only represent it. This symbol is then sent to your hand for recording. If you draw a symbol for a tree, it doesn't mean you can't draw. It means the enemy within intervened and dictated the drawing.

Modify boring shapes

When painting any item ask yourself, "Is the shape interesting?" This is different from asking if the item is interesting. It may be interesting because it belonged to your grandfather; however, this does not make its shape interesting. My grandfather's pocket watch is a very interesting artifact, but not an interesting shape. Our challenge as artists is not only to see an item's shape, but to analyze the shape for its visual interest and its ability to contribute to our painting. Some shapes are perfect and don't need modification. Often shapes need just a little adjusting to make them more interesting. Other shapes need a full makeover.

Good Shapes

Shapes are like people—some are interesting and interact with others, some are boring recluses who avoid interaction. Good artists create shapes that interact with the surrounding space and allow the space to move into the shapes.

Uninteresting Shapes

Imagine you want to include a rock and a bush in your painting. First look at the shapes. If the shapes are boring, as these are, you need to modify them.

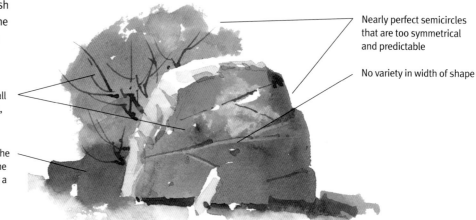

Nearly perfect semicircles that are too symmetrical and predictable

No variety in width of shape

No variety in edges (all are relatively uniform, unbroken and hard)

Neither the rock nor the bush interacts with the background, creating a static feeling.

Interesting Shapes

These shapes are more interesting than the first example. Neither the rock nor the bush is predictable. These shapes have various widths; they are thin in some places and wide in others. Both shapes interact with their background, which creates a dynamic sense of space on the picture plane.

Include a variety in edges: some hard, some soft, some ragged and some lost.

This shape is wide at one end and very narrow at the other.

Create plenty of interaction between shapes and surrounding space.

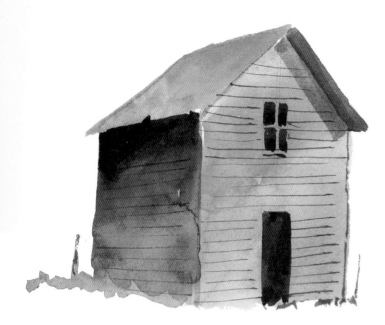

Boring Building Shape

This little building has quite a boring shape. Notice that it is self-contained—there's no place for the surrounding space to get in and interact with the shape. There are no parts of the shape that jut out into the space (the white of the paper). All of the edges are the same. Its height and width are approximately equal. It has no visual surprises.

Interesting Building Shape

There are several places where the building creates a sense of space or involvement: the chimney, the fence, the shadows in the foreground. These shapes break up the white of the paper the way landforms jutting into the sea create inlets and bays. This shape is wider than it is tall, again adding variation. It also varies in width from narrow at the top to wide in the middle, and then narrow at the bottom in the foreground. The edges also vary; some are hard, crisp, ragged, soft or even lost.

Involvement with space

Lost edges

Ragged edges

Narrow shapes

Place shapes into visual categories

When you name items you put them into intellectual categories. We all do this, but few people outside the field of art take note of an item's shape. Progress beyond the intellectual category and train yourself to put shapes into visual categories, such as:

▸ Shapes of light value

▸ Shapes of dark value

▸ Shapes of color

▸ Shapes of space

You can't paint good shapes if you are not aware of them. Train yourself to see interesting shapes and you will respond more to them when painting. Building a painting involves organizing shapes into a unified visual statement wherein each shape, like a piece in a puzzle, contributes to the whole. Good shapes are all around us; however, be aware that they tend to keep bad company. Everywhere you find an interesting shape, you will usually find a boring one, too.

Here are two paintings that were based on strong shapes.

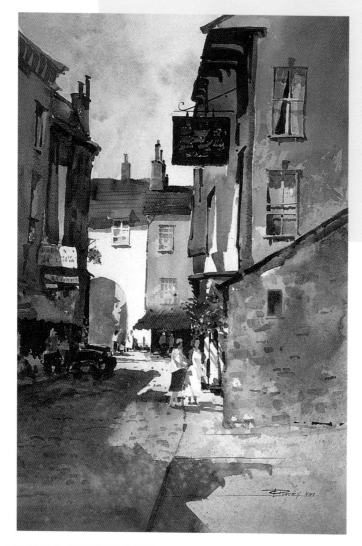

Streetside Shapes in Daytime

Several interesting shapes caught my eye in this little street in Ashburton, England. The most important was the light shape with the archway at the end of the street. In my painting, I increased the size of the archway for greater interest. The dark shape of shadow cast by the buildings onto the street also caught my eye, as did the shapes of the people. I loved the shape of the space with signs and chimneys pushing into it. Little complementary shapes of blue and orange also add interest to the scene.

ASHBURTON SIDE STREET ▸ Watercolor ▸ 27" × 19" (69cm × 48cm)

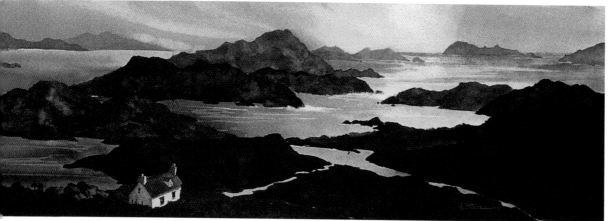

Seaside Shapes at Sunset

The intriguing shape of the light-struck sea as it interlocked with the dark shape of land at sunset was a visual treat for my wife and me when we arrived at this remote village on the north coast of Scotland.

BADCALL BAY ▸ Watercolor ▸ 11" × 28" (28cm × 71cm) ▸ Private collection

When I draw on location, I begin with whichever interesting shape first catches my eye. Then I add what is necessary and change any shapes to improve the composition. A camera cannot do that. You can't rely on it because it doesn't discern interesting shapes from boring ones.

In the following photos I have pointed out some of the interesting shapes and boring ones. Practice doing this yourself so you can edit with ease every time you select a subject to paint.

Overcome camera dependence

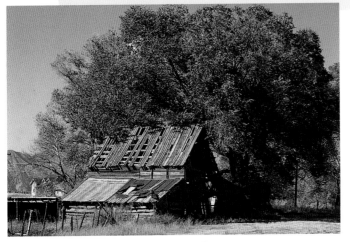

Determine Interesting and Boring Shapes
The most interesting shape here is a dark shape made up of the shadowed side of the barn, the tree trunks, the foliage in shadow and the shadow on the ground with fence posts. But the overall shape of the tree is boring because it is too round and looks like a large, uniform oval. The grassy area at the bottom is a boring light rectangle.

In a painting, I would create places where the space around the tree would push into it, making the shape of the tree more irregular. I would push the dark shadow on the grass down into the foreground light, creating better shapes out of the rectangle.

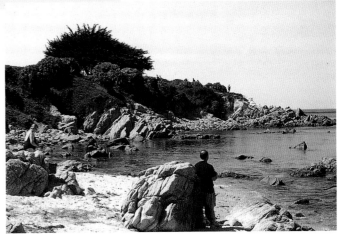

A Boring Shape Within an Interesting Seascape
Among the beautiful coastal shapes in this photo, a tree/shrub shape has perched itself on top of the rocks and looks just like a big hedgehog—a cute animal, but not the most interesting shape in the world. In a painting, create a better shape by pushing some of the dark out into the space and allowing the light space to cut into the dark. Adding another tree also might help.

Discover Hidden Interesting Shapes
Some shapes are fascinating just as they are; however, you have to be aware of them. Most people would simply pass up this beautiful shape and never notice it.

Practice altering shapes

If we see everything around us as shapes, and see ourselves as arrangers of shapes, then we will be free of the tyranny of the photo. We will feel at liberty to change any shape to suit our needs, move any shape to enhance our compositions, and add any color to a shape when we feel it is necessary.

Find a good shape and use your artist's brain to adjust it in several ways. Explore the characteristics of the shape and try out several possibilities. This is the joy of art. The excitement is not in the final product, but in the journey you take to get there.

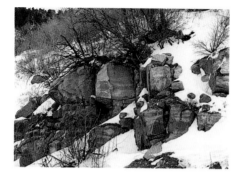

Reference Photo

The rocks in this photo create a very interesting shape; however, there are some areas that need changing. The background isn't doing anything for the rock forms. The dark shape is too big and too far away from the point of the rocks. You need to make the shape more interesting and bring it over where it can add to the excitement of the rocks. The straight diagonal line at the bottom of the rocks needs to be broken up and given some irregularity.

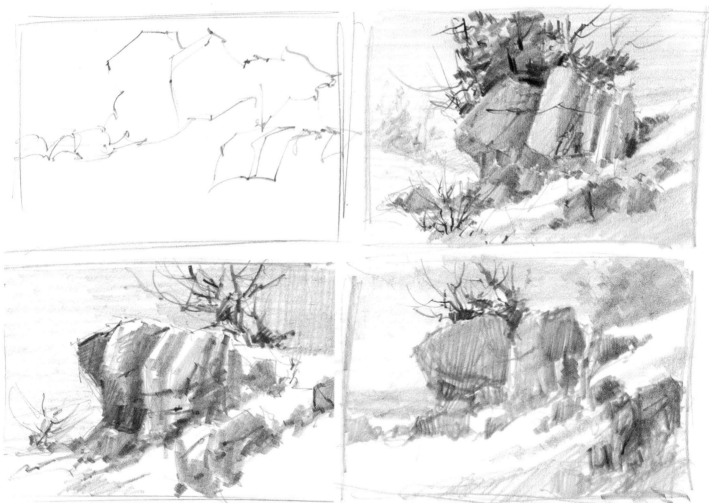

Experiment With Thumbnail Sketches

Start with a linear exploration, or basic line drawing of the shape. Place it in a format to see how it divides up the space.
Then try several variations, quick thumbnail studies that show what the shape will look like if you vary some of its characteristics.
In these sketches I have tried several types of the tree form, changed the configuration of the rocks and moved the trees.
Nothing in the photograph is sacred; you won't go to jail for changing anything.

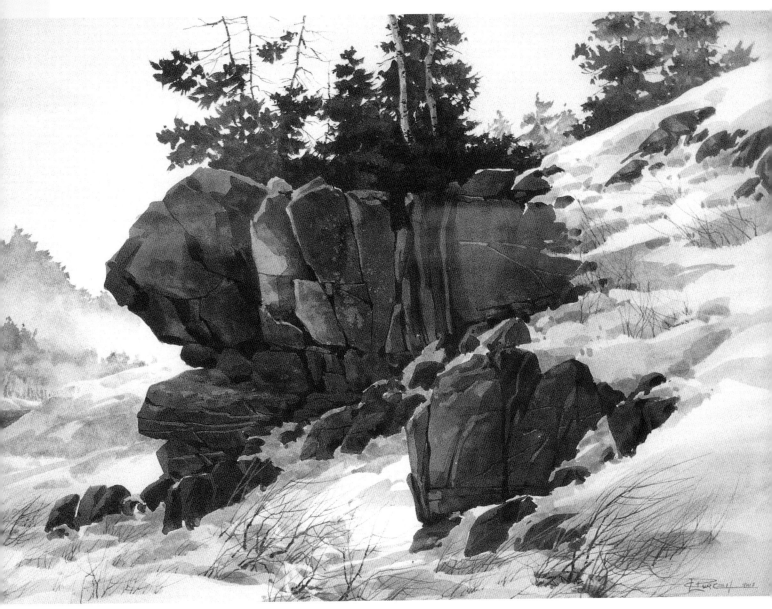

The Finished Painting

The painting is not the same as the photo. Does this make it unreal? No! It is a different reality than the photo. Think of the photo only as a springboard for ideas. The art occurs after you leave the springboard. In this new reality, the major lines from the left lead to the rock forms, and the dark trees provide an area of strong contrast where the rocks end.

NORTHERN EXPOSURE ▸ Watercolor ▸ 22" × 28" (56cm × 71cm) ▸ Private collection

A Lesson From a Master

The great Michelangelo is reported to have said after completing a statue of the Duke of Urbino for the Medici tombs, "What, it looks not like the Duke? Who will know a thousand years from now?" After nearly five hundred years we could safely add to that, "And who will care either." If changing the shape will enhance the artwork, it's OK to change it!

Resist the enemy's cloning tool

Anyone familiar with the computer software program Adobe Photoshop knows what the cloning tool is. It allows you to copy any section of a photo and repeat it somewhere else. For example, if you had a short section of fence in a photo, you could clone it to make one long fence. However, every post would be identical in length, width, height, color and value.

Your intellectual brain has a similar feature—it can register a sequence and repeat it. Remember, the enemy within is always looking for an opportunity to involve itself in the painting process. You give it the opportunity whenever you paint a sequence that can be repeated—fence posts, rocks, tree branches, bushes, grass blades, windowpanes and so on.

Once you paint the first one or two, the enemy within jumps in and says, "I got it, let me do that!" And it does.

The next time the enemy within tries to interject its oversimplified versions into the painting process, deter it by basing your shapes on observation and assuming nothing. For instance, if you were looking at a house and a tree, like the scene on this page, ask yourself what you actually see. What happens along the bottom edge of the building shape when it meets the lighter or darker shape of ground? At what angle do the tree limbs leave their parent branch, and what kind of rhythm do they have? What variations in value and color do I see on the side of the building?

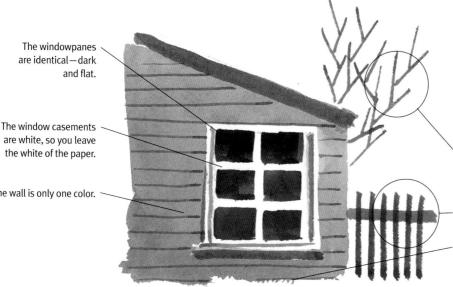

The windowpanes are identical—dark and flat.

The window casements are white, so you leave the white of the paper.

The wall is only one color.

How Your Intellectual Brain Wants to Paint

The intellectual brain taints your visual thinking. It wants to oversimplify and take the easy way out when painting the images it interprets. The elements in this image are painted not from observation but from previous knowledge.

All the tree branches are comprised of just two lines: one emerging from the center of the other at a 45-degree angle.

All fence posts are equal height and equidistant.

The building rests parallel to the ground, so the bottom of the building should be a straight line where it meets the ground.

How Your Artist's Brain Wants to Paint

Careful observation and the ability to make visual revisions are the keys to overcoming the enemy within.

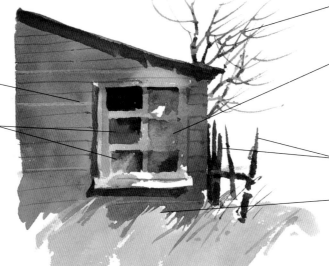

Make the wall varied in color.

Make every pane different to avoid boredom.

Vary the position and angles of the branches, to create rhythm.

Carry the color of the wall over the casements, leaving just a few spots of white. This ties the window to the wall, making them better relate to one another.

Vary the height and spacing of the fence posts.

Imply the bottom of the building with a varied top edge of grasses overlapping it.

Be a collector of shapes

Master watercolorist Edgar Whitney is reported to have said that we should become collectors of shapes and inventors of symbols. I have discussed the kind of visual symbols, based on observation, that I believe he was talking about. Now a few words about collecting shapes.

Some people collect stamps, while others collect toys, or baseball cards. I collect shapes. When my wife Nan and I are on trips, she has to remind me to take "memorabilia" shots. I am always looking for good shapes that will work well in paintings. It requires a conscious shift in thinking for me to take the photos that go into a photo album.

Begin your collection of shapes now. Collect them with your sketchbook and pencil, or your brush. The more you train yourself to look for interesting shapes, the more natural it becomes. You will find yourself seeing the world a little differently. Whereas before you looked for things of interest, now it won't matter what the thing is, only the shape it has. Here are a few examples from my collection. I hope you find them interesting.

I collected these figure shapes with my paintbrush on a bustling street. Collecting moving figure shapes precludes the collecting of details. Respond to general shapes of dark and light color with deliberate brushstrokes, allowing the shapes bleed into each other.

These wonderful overlapping shapes were collected in Clovelley, Devon, England, with pencil.

I really like the dark and light shapes formed by the light headstones and the dark tree. I balanced these with the light figure shape in the archway and a suggestion of the stained glass window shapes on the left.

Focus on shapes to make
a STRONGER PAINTING

materials

PAPER

Arches 140-lb
(300gsm) rough

BRUSHES

Nos. 6, 8 and 12 rounds

1-inch (25mm) and
2-inch (51mm) flats

WATERCOLORS

Cobalt Violet

Manganese Blue

Permanent Rose

Quinacridone
Burnt Orange

Quinacridone Gold

Quinacridone Sienna

OTHER

6B pencil

Sketchbook

Hair dryer

Paper towels

WATERCOLOR DEMONSTRATION

Here is a simple subject made of large shapes. Remember, you can either approach it from an intellectual standpoint—allowing the enemy to name the grass, road and so on—or you can use your artist's brain to focus your attention on the shapes, the colors within those shapes and how their edges convey essential information.

Reference Photo

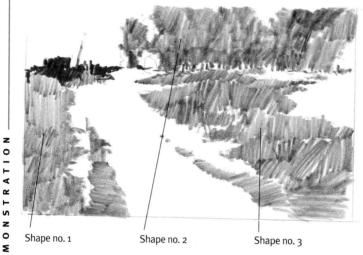

Shape no. 1 Shape no. 2 Shape no. 3

Value Sketch

Create a value sketch by reducing the scene in the photo to three basic shapes. Each is interesting and needs little changing. The first shape is formed by the grasses on the left, ending with the buildings. The second shape is formed by trees at the top of the composition, and the third shape is formed by grasses on the right side. Draw these shapes carefully rather than drawing objects. This allows you to capture the heart of the scene—what gives it visual impact. Place the horizon line higher in the composition to avoid dividing the picture in half. This will mean shortening the height of the shape no. 2.

Focus attention on the edge of the shapes, not the interior.

The edge of this shape identifies the fence, building and so on.

Let the edge of the dark value define grass.

Ragged edges define the foliage

The darker value will tie this to shape no. 1.

Leave pieces of light for spaces between trees.

Extend the shape to the edge of your paper.

1 Paint the First Shape

Load a no. 12 round with a juicy mixture of Quinacridone Burnt Orange and Cobalt Violet. With the painting support tilted about 30 degrees, paint the top part of shape no. 1. There should be a bead of color at the bottom of the painted area; if not, you need to use more water.

Rinse the brush and load it with Quinacridone Sienna. Begin painting along the edge of the bead, allowing the first color to run down into the new color. Continue the wash down your paper, recharging the brush with a new mixture of Quinacridone Gold and Manganese Blue.

At the bottom, carry the wash over to the dark shape of the rut in the road. Without a break in the wash, carry it on up this shape until you reach its point. You now have one single shape with varying colors. The top is geometric, revealing the silhouette of a building and fence. At the bottom edge of the darkest part, paint a few strokes of a dark shade to reveal grass.

2 Establish Shape No. 2

Load a 1-inch (25mm) flat with Quinacridone Sienna. Hold it horizontally and drag the color with the edge of the brush to produce a ragged edge for the tree shape on the left. While that is still wet, load a no. 12 round with Quinacridone Burnt Orange and Cobalt Violet and touch this mixture into the base of the shape you just created.

With a 1-inch (25mm) flat loaded with Quinacridone Sienna, begin the larger portion of the tree shape, moving from left to right. Tilting the board to make the left side about 30 degrees higher will allow the paint to puddle in the direction you will be traveling. As you carry the bead along this shape, charge it with some Permanent Rose and Quinacridone Burnt Orange. Then add Cobalt Violet followed by Manganese Blue. Leave some light patches between tree trunks.

Once you reach the right side of the tree shape, drag the brush along its edge again to produce a ragged edge. This gives the impression of foliage without too much detail. Extend the bottom of the shape until it touches the right side of the paper. Now we have created a single shape that reads as a number of trees. It is an interesting shape, with places where the surrounding space moves into it. The shape also changes color from very warm on the left to cool on the right.

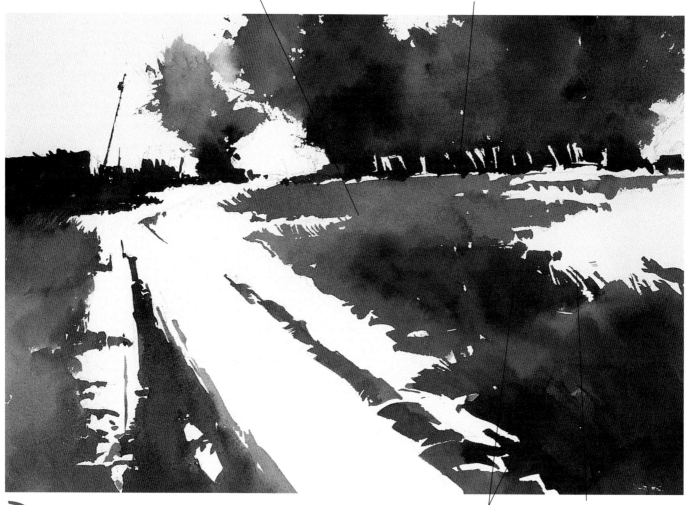

Quinacridone Gold adds excitement to the color near the focal point.

Merge the shapes here.

Red and violet cool the shape as it gets farther from the focal area.

The edge of the shape, not a thousand grass blades, describes the grass.

3 Move On to Shape No. 3

This shape is not as clearly defined in the reference photo, leaving itself open to interpretation. I have chosen to draw it with smaller intrusions of white along its left side. The choice is yours, but it must be interesting.

Load a 1-inch (25mm) flat with a mixture of Quinacridone Sienna and Cobalt Violet and begin the shape at the right edge of the paper just below the tree shape. Touch just the tip edge of the brush to your paper and drag it sideways with a somewhat jerky motion to produce a stroke of varied width. About halfway along the base of shape no. 2, merge the wash with the tree shapes so they connect. As you approach the left side of the shape, charge the brush with Quinacridone Gold in addition to the other mix. Carry the bead of color down to the bottom, changing the colors as you go by introducing Permanent Rose and Cobalt Violet.

Keep the interior of the shape simple. Never go back into a previous stroke; this will muddy it. Break up the edge of the shape in places with strokes indicating grass. If the edges of the shape are carefully treated, you won't need much more detail. Notice how well you can read the subject at this point even though there are no supporting details. The painting is strong because of its shapes.

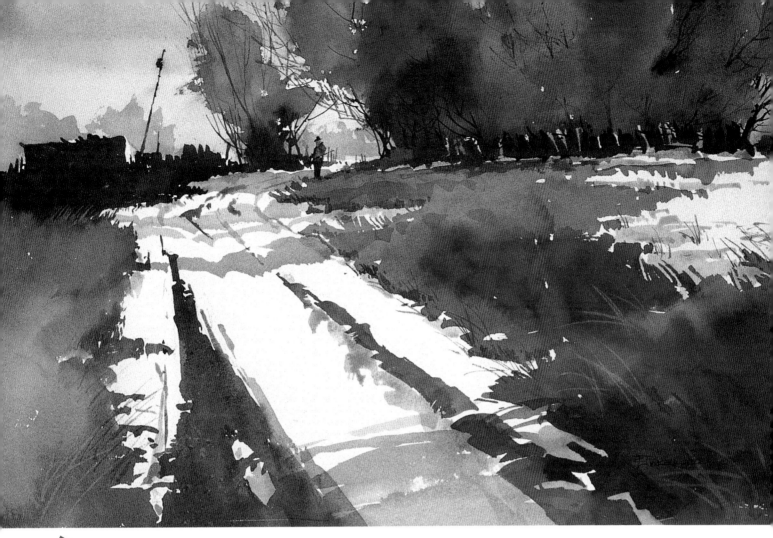

4 Add the Finishing Details

Think of the details as decorations on shapes—little touches that help explain the shape. Add a few calligraphic lines with a no. 6 round to describe tree branches. Add a few more in the opening where the road leads, and place a tree trunk on this side. On the right side, add a tree trunk and limbs. Along the edge of the grass shapes, add a few strokes to indicate grass.

With a no. 12 round, paint the shadows across the road using Cobalt Violet and Manganese Blue with a touch of Permanent Rose. Make sure the shadows undulate over the surface of the road, defining the road's contours. With a pointed no. 12 round, paint some shadows at the edge of the snow with Manganese Blue and Permanent Rose.

Add the background sky last. With a 2-inch (51mm) flat and a light mixture of Cobalt Violet and Quinacridone Burnt Orange, quickly paint the background directly above the trees. Dry it immediately with a hair dryer to minimize any bleeding of color. With a pointed no. 8 round and clear water, paint a few grass blades in the interior of the shapes and then lift them out with a paper towel. These details enhance the shapes but don't alter the structure of the painting.

ALONG THE FARM ROAD ▸ Watercolor ▸ 19" × 27" (48cm × 69cm)

POINTS TO Remember ☞

- Everything you paint is a shape.
- An item may be interesting in content, but have a boring shape.
- Instead of seeing items, notice shapes—specifically shapes of light, dark, color and space.
- You can change any shape to make it more interesting; your camera cannot.
- For interesting shapes, avoid perfect, predictable symmetry and vary the quality of the edges.
- Lavish attention on creating the edge of shapes, not surface details.

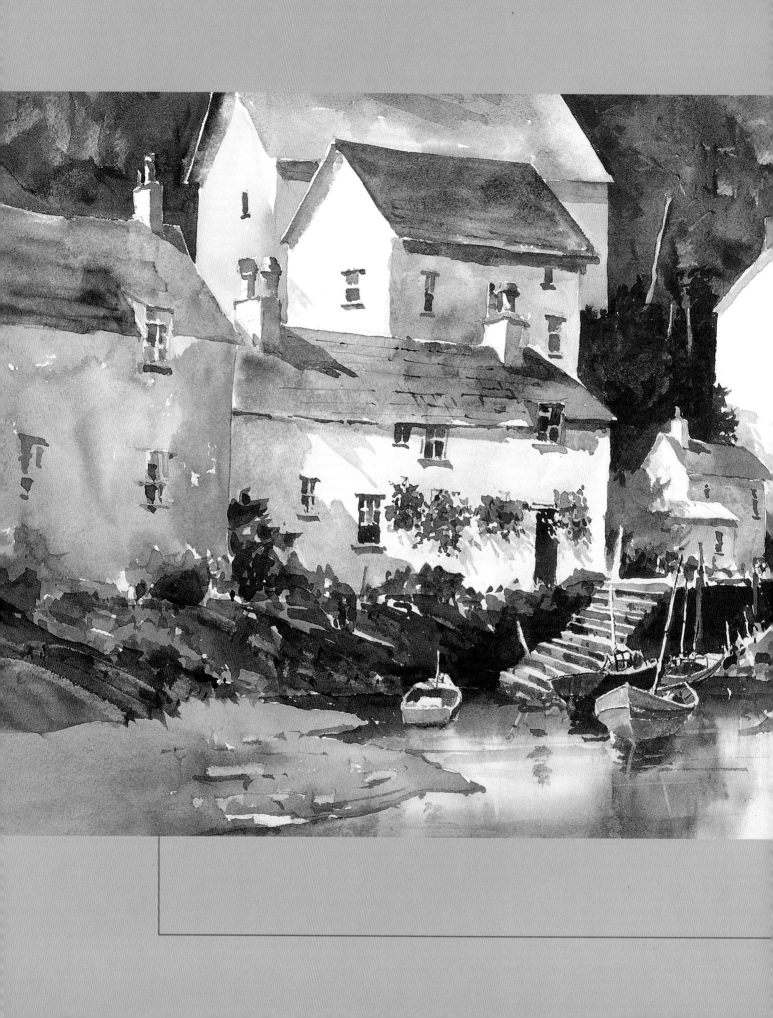

seeing the
SHAPE OF SPACE

Your ability to compose or design paintings is insepa-rably connected to your ability to see shapes. The shapes of the space around the objects you see are equally as important as the shapes of the objects themselves. These shapes are a vital part of your painting. I prefer calling the kinds of shapes we will be discussing in this chapter "shapes of space" rather than negative shapes. "Shapes of space" is a more positive reference—nothing about them is negative. They are one of the most posi-tive design aspects with which you can work.

Instead of "negative" painting, think of it as defining objects by painting the space around them. The enemy within wants you to believe that every-thing needed to define any object is within or on the object. This is false. Often the most revealing detail is at the edge of a form where the surrounding space defines it.

LOW TIDE IN POLPERRO ▸ Watercolor ▸ 14" × 19" (36cm × 48cm)

Designing shapes of space

If we think of the space around an item as a space shape, it doesn't matter what it is specifically. Therefore, I consciously try to design the shape of the space around any object. Sometimes it is part of a larger object, or it may just be sky. The important aspect is to see it as a shape. Whether it receives a lot of color, texture and detail, or whether it is a simple wash, it is still one of the shapes in the painting.

Following are good reasons to make the shapes of space part of your thinking:

▸ They share an edge with a positive shape. If the edge of the space shape is interesting, then the edge of the positive item also will be interesting.

▸ These spaces easier to see as shapes than are nameable items, because we have no preconceived ideas about how they should look. This makes them easier to change. If we change the space shape, we automatically change the item shape.

▸ Dealing with the space shape helps us avoid awkward tangents and boring shapes. A tangent occurs when a line touches another line but does not intersect it. For example, if the line from a distant hill coincides with the roof line of a building, it creates an awkward tangent because, at that point, the roof and the hill occupy the same space and one does not appear to overlap the other.

▸ The shape of space often defines the character of the positive items.

The dark of the buildings functions as a negative shape or space shape defining the clothesline.

This important shape of space defines the sheets on the line as well as the figure.

Drawing these space shapes is easier than drawing the figure. When you have drawn these spaces, you have correctly drawn the position of the arm in relation to the body, the legs and the laundry tub.

Viewing Positive and Negative Shapes

If the sky is a negative shape and the buildings are positive shapes, then what do we call the shape of dark around the clothesline? The positive shape just became a negative shape. The sky is a light space shape, and the buildings become a shape of dark space around the clothesline.

WASHDAY ▸ Watercolor ▸ 14" × 19" (36cm × 48cm)

For example, if you correctly draw the shape of space between a figure's arm and torso, you've automatically drawn the edge of the arm in relationship to the torso.

► Drawing the shape of the space around an item is often easier than drawing the item itself. It helps us avoid mistakes in drawing that are the result of the enemy within, which substitutes stored knowledge for visual facts. This is especially true when drawing the human figure or other subjects where perspective presents us with a foreshortened view.

Positive Shapes Can Act as Shapes of Space

I painted this in the quaint North Devon coastal fishing village of Clovelly in England. While walking down the stone steps, I looked back and saw the light falling on them. The white shape of the building at the top captivated me. The two ladies who came home while I was painting were the icing on the cake.

The white shape of the building actually functions as a space around the dark figure. The doorway becomes a dark shape of space behind the other figure. This is an example where the positive shape of a building becomes a negative shape when a figure is painted over it. Consider the space around any object as a shape for you to design—it is as important as the shape of the object. Do you see how the light shape interacts with the darker shape?

Coming Home in Clovelly
Watercolor
21" × 14" (53cm × 36cm)

Make the shape of space enhance your subject

Remember how the small space is between the finger of God and the finger of Adam in Michelangelo's painting of the creation of Adam in the Sistine Chapel? That tiny space creates an enormous tension that seems to spiritually unite God and Adam. Shapes of space possess that intensity of electric energy. Negative space can either unite two items with dynamic tension between them, or it can push them apart with the same force.

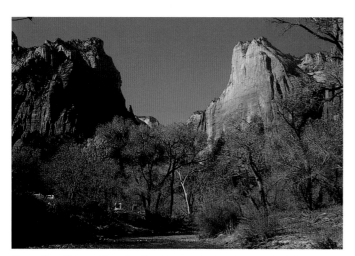

Negative Space Repels Structures
This is one of my favorite spots to paint in beautiful Zion Canyon in southern Utah. Notice how the space between the two towering rock formations seems to push them away from each other. This is because the space shape between them is as large as the positive rock forms. The energy in the space is a force driving the two figures apart.

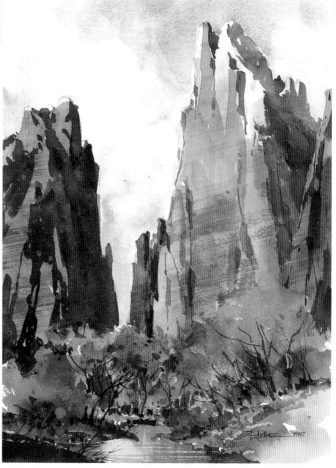

Shrinking Negative Space Helps Subjects Work Together
I made several small changes to the subject, but the major enhancement was simply making the space shape between the rocks smaller than the peaks. Now the two are working together. The space between them becomes a dynamic space that seems to pull the two together, rather than an empty space forcing them apart. Space then is not "nothing;" it is energy and force. This is a life principle. Often the little things in a relationship that seem to have no substance can end up becoming so large that they drive two people apart. Make the space work for you by creating energy of attraction between subjects.

ZION CANYON ▶ Watercolor ▶ 13" × 10" (33cm × 25cm)

The space shape of the sky is too far away from the subject to enhance it.

The hill creates a second shape of space between the subject and the sky.

The background and foreground meet in an awkward tangent.

Too much surrounding space engulfs the subject.

Reference Photo

This old mine in southern Utah has a very interesting shape; however, there are a few problems. There are two shapes of space behind the subject: the sky and the hill. The trees along the top of the hill create a line between them that does nothing for the subject. In fact, it takes attention away from the subject. Also, by just kissing the top of the A-frame, the hill creates an awkward tangent. The other space-shape problem here is the abundance of space around the sides and bottom of the subject. The subject ends up floating in this space instead of being defined by it. Beginning painters are often confronted with this problem. By not considering the shape of the surrounding space, you are forced to surgically amputate the excess parts of the painting after it's completed.

Problems Solved

Here I have consciously considered the shape of the space around the subject. Eliminating the hill created one background space shape that now shares an edge with the subject. I also made a few adjustments to the space shape by adding a few poles to create more places where the subject's shape interacts with the space. I moved the right edge of the painting closer to the subject shape to create an interesting ending to the space shape. I added some vent pipes on the buildings to break up the line between space and subject shape. I also decreased the space at the bottom. Now the shape of the subject activates the space by touching the sides and bottom of the painting.

HORN SILVER
Watercolor
14" × 28" (28cm × 71cm)

The amount of space on the right and on the bottom is decreased, allowing the subject to be dominant instead of the space.

Here are additional places where the object interacts with the space.

Vent pipes are added to break up the line between the object (roof) and the space (sky).

Combine photos to create ideal shapes

An artist's duty does not involve painting scenes just as they are. Painters aren't recorders. It is more important for you to express what you feel about your world. A camera can record exactly what is there, but only you can record your perceptions and feelings about a subject.

My best advice is to be passionate about painting and get in touch with that passion. Look at a subject and see the possibilities for a painting. If you look for the perfect composition, you will do a lot of searching and a little painting. Once you realize that you are free to rearrange and edit the material, you will smash the shackles of copying and revel in your freedom of expression.

The possibility of a painting often stems from a combination of elements in two or three photos I have taken. This new reality looks the way I wish the scene had looked. Here's how it works:

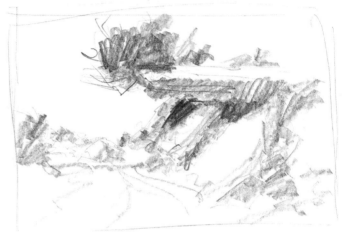

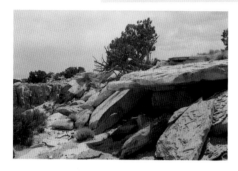

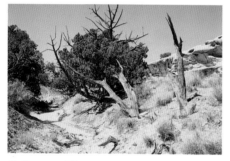

Reference Photos

Here is a photo of a wonderful rock formation, and another that focuses on a juniper tree in the same desert scene. This scene has some very good points and one very big problem. Notice that in the first photo, the line that divides the space shape of the sky from the shape of the rocks is almost perfectly straight. The line is broken only once by the tree form.

Now imagine the sky shape coming around the main rock form. What would that do to the rocks? Let's see.

Rough Sketch

Roughly sketch the scene to see how combining the two photos would look. This is just a quick thumbnail to "try on" the composition; if it doesn't work, do another. Even in this rough draft we can see the dynamic potential of the scene without that bothersome continuous line. The combined references make a good composition with interesting shapes, so let's take it one step further.

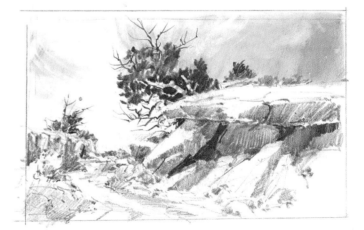

Final Sketch

Let's plan the composition some more. Borrow a better tree from the second photo because it has a more irregular configuration and interacts with the surrounding space. Now do another more complete drawing. Everything should help draw your eye to the point where the rock meets the tree, the focal point of the painting. With this plan, the painting has a much better chance of success.

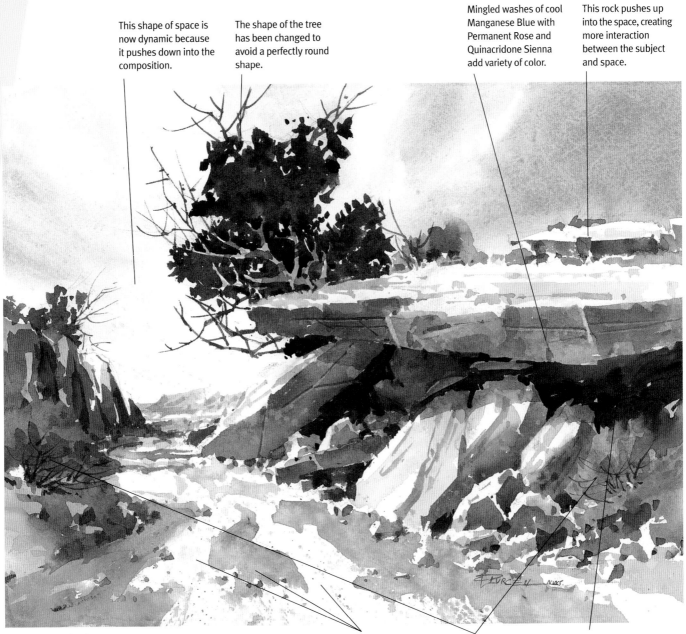

This shape of space is now dynamic because it pushes down into the composition.

The shape of the tree has been changed to avoid a perfectly round shape.

Mingled washes of cool Manganese Blue with Permanent Rose and Quinacridone Sienna add variety of color.

This rock pushes up into the space, creating more interaction between the subject and space.

The light and dark patterns in the wash pick us up and lead us back to the focal point.

These bushes provide a repeat of the blue-greens found in the sky and the main tree.

The dark shape of space defines the lighter rocks.

Finished Painting

I have always felt drawn to these trees that seem to defy all odds and grow where nothing else could. To me they are symbols of the tenacity and power of life. The changes made to the composition support this theme.

TRIUMPH OF LIFE ▸ Watercolor ▸ 10" × 13" (25cm × 33cm)

Define light subject shapes
WITH DARKER SHAPES OF SPACE

MATERIALS

PAPER
Arches 140-lb
(300gsm) rough

BRUSHES
Nos. 6 and 12 rounds
1-inch (25mm) flat

WATERCOLORS
Manganese Blue
Quinacridone
Burnt Orange
Quinacridone Gold
Quinacridone Sienna
Sap Green
Ultramarine Blue

OTHER
6B pencil
Sketchbook
Paper towels

In this demonstration focusing on leaves, you must fight the urge to give into your intellectual brain, which will want to repeat the same leaf shape over and over again. Instead, we will use the dark shapes of space around the leaves to really define them.

These dark shapes give information about the leaves' edges.

Each of these little dark spaces defines the edges of three different forms: two leaves and a stem by one, and three leaves by the other.

Reference Photo

1 Draw Some of the Leaf Shapes and Space Shapes

Don't attempt an exact replica of these leaves or you will be bored silly. Instead, draw some of the leaves and spaces on the paper so you'll know where you are headed. Then study the characteristics of the light and dark shapes. In this case, the light shapes consist of leaves and patches of light falling on them. The dark shapes are the background space and the darker leaves.

WATERCOLOR DEMONSTRATION

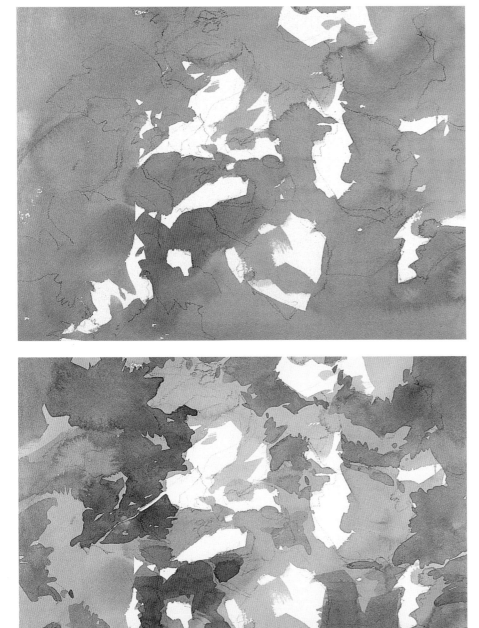

2 Establish Overall Color and Shape With First Wash

Lay down a unifying wash to establish the mood and general color. Our painting will be sunnier than the reference photo. Begin in the upper left with Sap Green and Manganese Blue using a 1-inch (25mm) flat. Leave areas of sparkling light as you progress. Add Quinacridone Sienna and Quinacridone Gold to the mix as you near the center.

3 Define Larger Shapes and Patterns

Don't try to control this stage by painting individual leaves. Fear of losing an edge or losing control will make you choke up and do a colored drawing. Instead, carve around light shapes with the darker values. Using a no. 12 round, apply the same colors from the previous step, but with a little less water and a little more pigment.

Leave light patches, not whole leaves. Define the edge of a leaf with a cast shadow. Define edges, but never an entire leaf. That is not how we see them. Define parts and leave places for one leaf to merge with another. Add just a little Quinacridone Burnt Orange to the area just below and to the left of the center of the painting, which will be our focal point.

4 Bring the Scene Into Focus

This could be the final stage, depending on how detailed you want the painting. The idea is not to count leaves, but to create the impression of layers of leaves and convey the feeling of growth. If you tell the viewer everything, you dominate the conversation and the possibility of communication is lost.

Still using the no. 12 round, darken the background space and define a few leaves in the process. A very dark green can be made with Sap Green, Quinacridone Burnt Orange and a bit of Ultramarine Blue. Go into the focal point area to define a few edges and leave a few bits of vine. Some of these are nothing but quick brushstrokes based on the kinds of dark shapes that exist in the reference photo. Keep the contrast to a minimum in the outlying areas; don't draw your viewer's eye to the edges of your composition because it may leave the painting.

A simple area shape such as this makes sense out of this somewhat abstract mass of leaves. These shapes of space magically make the leaves pop out.

Add Final Details

This final stage brings enough areas into focus to convince the viewers that they are seeing more than they think. The shapes are the key—if they are right, less detail is needed. Even when looking at the real subject, we see fewer entire leaves than we think. With the right context and a few details, the viewer will fill in the rest.

With a mixture of Ultramarine Blue, Quinacridone Burnt Orange and very little water, begin to further define some of the leaves and stems in the focal area. You will end up eliminating some of the leaves already created. Don't approach this with the feeling that anything you previously did is sacred. At this point, watch the painting, not the photo. The photo will only confuse you because it is not the same.

Create some soft edges here and there. Place single strokes and watch details appear. Add a few suggestions of veins in some of the leaves by painting them with clean water and a no. 6 round, then wiping with a paper towel. Paint some others with a slightly darker version of the leaf color. The enemy within wants you to make these much darker than they should be; don't do it. My rule for surface detail is to make the details just a little darker than the surface they are on.

Notice that many of the shapes left for leaves are not typical leaf shapes. But look at the reference photo again and see how many shapes are not exactly leaf shapes. Base your painting on observation, not intellectual symbols.

LEAF STUDY ▸ Watercolor ▸ 14" × 21" (28cm × 53cm)

Adjust subject and space shapes
FOR A STRONGER COMPOSITION

materials

PAPER

Arches 140-lb.
(300gsm) rough

BRUSHES

Nos. 6 and 12 rounds

1-inch (25mm) flat

WATERCOLORS

Cadmium Red Light

Carbazole Violet

Manganese Blue

Quinacridone Gold

Quinacridone Sienna

Sap Green

OTHER

6B pencil

Sketchbook

Paper towels

Palette knife

Spray bottle

When I recall this scene, I remember the sound of the stream gurgling along at the foot of these towering pines, the scent of fresh pine in the air and the warm sun on my face. This is what I wanted to convey in my painting. To capture the excitement of the moment, we'll have to make some changes to the scene my camera recorded.

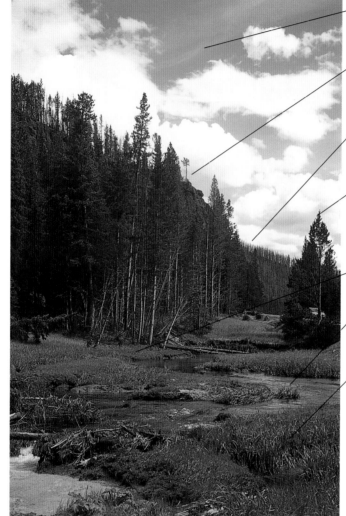

This space shape is basically a large triangle with a varied bottom edge. It will be a key to vitalizing the composition.

This edge between the object shape (trees) and space shape (sky) weakens this composition the most because it lacks enough interaction with sky shape to make it more exciting.

The background mountain shape has a top edge which nearly continues the edge of the large tree mass. It needs a different angle.

This tree is well placed because it stops the downward movement of the diagonal line between the sky and the large mass of trees before it reaches the edge. However, it is a boring triangle shape that needs adjustment.

The middle-ground shape is interesting and provides a nice light area at the base of the dark.

The wonderful shape of the stream brings you back slowly through a series of turns to point where the large tree mass shape ends. This is a focal point.

This large, simple foreground shape works well. If we keep it somewhat darker, it will help establish the ground plane.

WATERCOLOR DEMONSTRATION

Reference Photo

Let's analyze the shapes of this scene. We'll want to keep the number of shapes down to fewer than ten; too many shapes will confuse the viewer, and probably you, too, as you're painting. You won't remember which one was the focus of the painting.

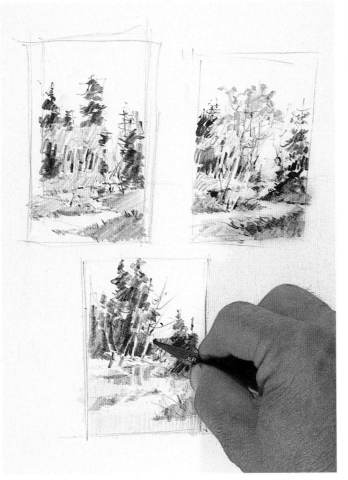

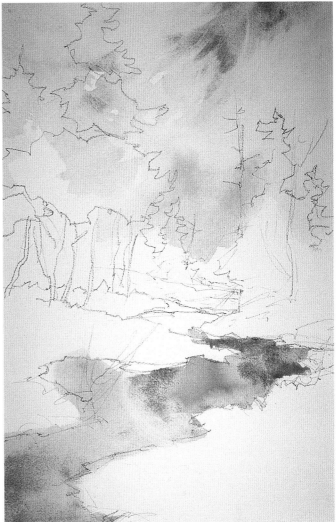

Thumbnail Sketch

Try several thumbnails to determine the best arrangement of the masses and develop some different solutions to the problem of the boring edge between the tree and sky shapes. Notice how I am holding the pencil flat rather than in the normal writing position. This helps me lay in broad shapes of value and keeps me from getting bogged down in picky details. A tight grip on the pencil causes your brain to shift to a consideration of tighter, smaller items.

I liked the top left drawing best; it was the most interesting, having a good breakup of space and a range of values.

1 Make a Drawing and Lay In the Foundation Colors

Transfer your plan to the stretched watercolor paper. Sketch a contour line drawing with a 6B pencil to identify the main shapes. Notice that I have drawn the pine trees as groups of shapes.

Begin painting, working from light to dark. Since the tree forms will be dark, paint the sky first. With your flat brush, quickly lay in a loose pattern for the sky with Manganese Blue and Quinacridone Sienna. Use Quinacridone Sienna with a lot of water to warm up the cloud areas, which should reflect the warmth of the earth. While this is still wet, use a clean, damp brush—one that has been rinsed out and then squeezed between paper towels—to lift out some light edges for the clouds. You want a mixture of soft and hard edges.

With the same colors, paint the stream, which should reflect the scenery. Bringing these colors down into the foreground will also help unite the painting.

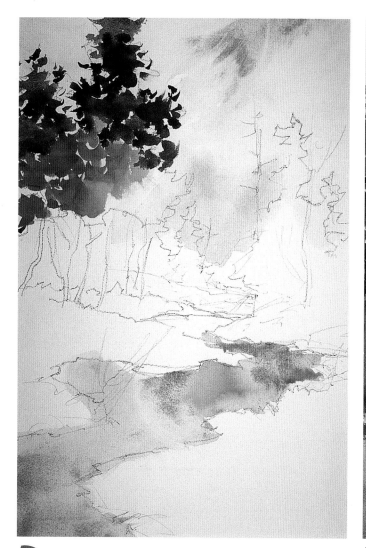

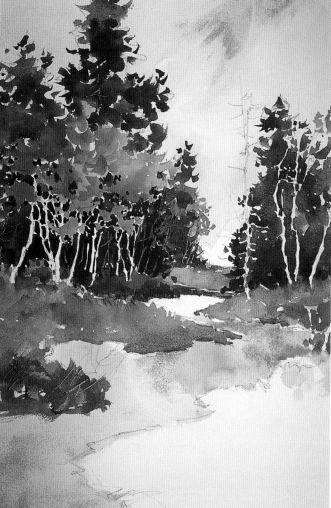

2 Begin the First Mass

Create the group of trees on the left using a no. 12 round and a mixture of Sap Green and Manganese Blue. Add a little Quinacridone Sienna here and there to warm it up. Paint around the white tree trunks. While it is still wet, drop in the autumn colors with Cadmium Red Light, Quinacridone Gold and Quinacridone Sienna. Notice the suggestion of detail is at the edge of the foliage shapes, not within the interior.

3 Continue the Background Tree Shapes and Begin the Middle Ground

Continue painting the major mass down the left side with your no. 12 round, changing color as you go. The middle ground is a mixture of Quinacridone Gold, Quinacridone Rose and then Manganese Blue. Use plenty of water and pigment so you can move the bead of color around. Mingled washes provide wonderful color transitions. Before the wash dries, push some of the paint around with the edge of a palette knife to add a little texture.

Begin the tree mass on the right, adding some variety with a little Quinacridone Gold and Carbazole Violet and leaving bits of white paper showing to add sparkle. While the dark color at the base of the mass is still wet, paint the lighter green ground with some Sap Green and Manganese Blue. The soft edge will provide a better transition between the horizontal ground and the vertical trees. Remember, change color every time you re-charge your brush. Once again, the palette knife can add a little forest texture to the wash.

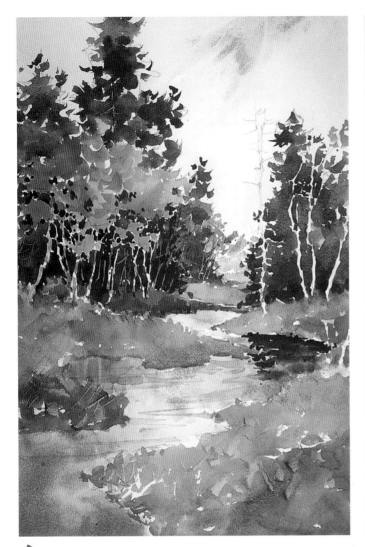

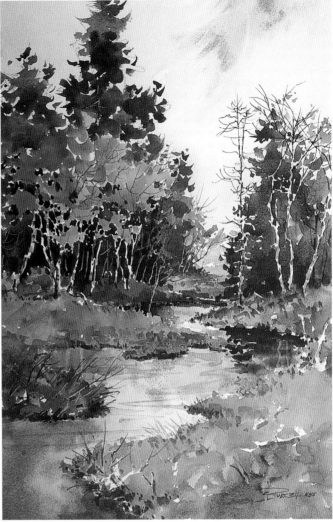

4 Head for the Foreground

Bring the wash on down into the foreground beginning with some Quinacridone Sienna, then adding Manganese Blue and Quinacridone Gold. Along the left where it meets the water, switch back to Quinacridone Sienna. Keep the lower right less vibrant. You can dull the Sap Green and Manganese Blue mixture with a touch of Quinacridone Sienna. We don't want attention in the corner.

Now add a suggestion of distant mountains in the gap between the two major tree masses with a mixture of Manganese Blue and Quinacridone Rose. Wet the stream with clean water and a 1-inch flat, and with a no. 12 round drop in the reflections from the dark trees and the autumn foliage. Add a little Manganese Blue in the middle as it reflects the sky, and darken the foreground water with Ultramarine Blue. Add a few horizontal strokes. Remember that the reflections are vertical, but the water is horizontal; you need both.

5 Add Final Details

Details are meant to explain shapes. You don't need too many. Add a little dark at the edge of the ground on the left where it meets the water. With a no. 6 round and a mixture of Manganese Blue and Quinacridone Rose, add some shadows across the white trunks. If you wish to scrape out lines and texture with a palette knife but the wash is already dry, simply re-wet it with a spray bottle and scrape in the texture. Use your no. 6 round and a mixture of Carbazole Violet and Quinacridone Burnt Orange to add the calligraphy for the dead pine and other branches.

SPLASH OF AUTUMN ▸ Watercolor ▸ 13" × 21" (33cm × 53cm)

POINTS TO REMEMBER ☞

▸ The space around an object is also a shape, usually referred to as a "negative shape."

▸ The shape of space often defines objects.

▸ The shape of the space around objects is often easier to design than the objects themselves. An interesting shape of space guarantees an interesting shape for the positive objects.

▸ The space around an object is often another object.

▸ If you can't see the shape of the space around your subject, you probably have too much space.

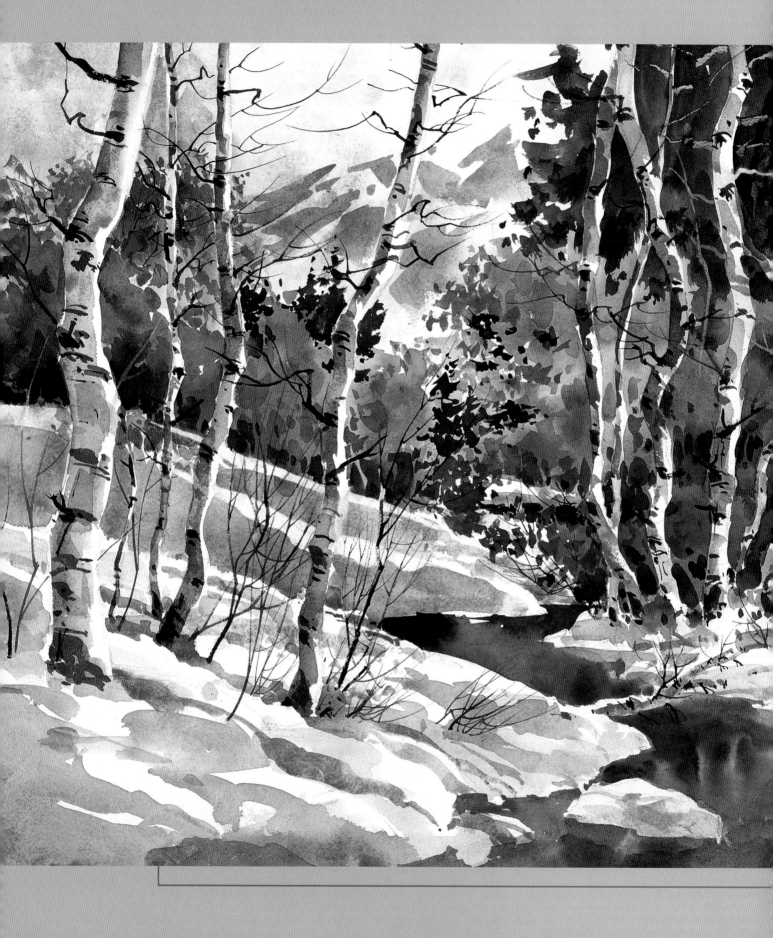

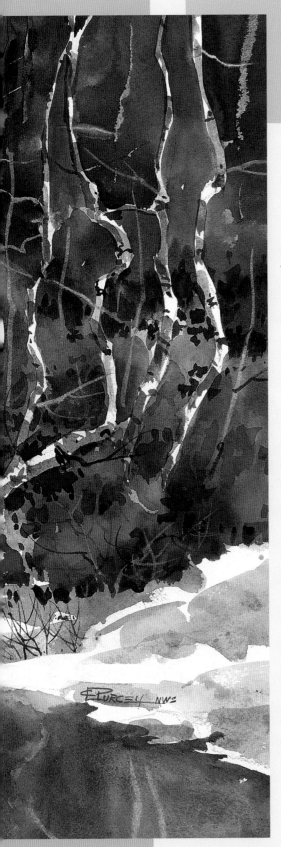

seeing SHAPES OF VALUE

In training yourself to see the four categories of shapes listed on page 50, the most powerful tool you can cultivate is the ability to simplify your subject into shapes of value. Doing this turns hundreds of items into a few simple shapes for painting. Acquire the habit of squinting. This may cause wrinkles at the corner of your eyes, but it eliminates detail and allows you to see big shapes of dark value more easily.

You read shapes by seeing differences in value, which is a critical art skill. At first your intellectual desire to separate all the items might interfere, but you will overcome this by persistently using your artist's brain. You are deprogramming your brain from what you learned as a child. Remember the coloring books you enjoyed when you were young? Each item was clearly outlined in black and you were encouraged not to go over the line. Now you have to unlearn all of that training to see shapes of value.

EARLY WINTER ▸ Watercolor ▸ 32" × 40" (81cm × 102cm) ▸ Private collection

See dark shapes

Every time we approach a subject we are faced with the same dilemma: The enemy within wants us to see it as a collection of nameable items, while the artist's brain wants to see it as a group of shapes.

Squint your eyes while looking at these photos to move past the details and see the larger dark shapes. It may be helpful to view the page upside down. This further separates you from the pictorial context and allows you to focus on the shapes.

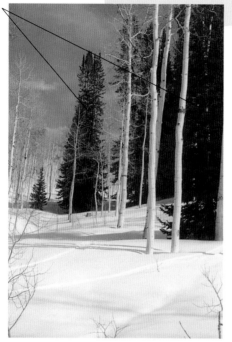

Several trees compose these dark shapes.

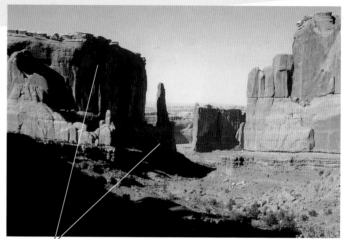

We see the shadows as one dark shape.

The dark value unites both buildings into one shape.

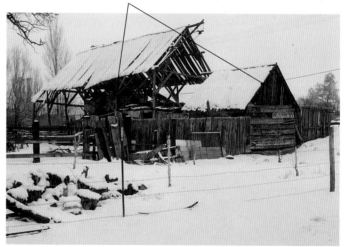

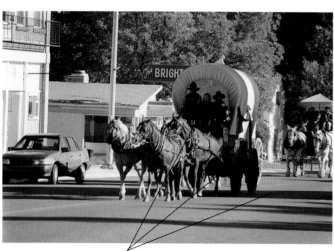

The figures, wagon wheels and shadow all form one shape. A single value can pull multiple different items into one strong shape. Separating each item as you paint will destroy this large shape.

Once you can see the dark shapes, you can use your artist's brain to determine what a shape needs to make it more interesting in your composition. These changes usually involve:

▸ Adding places where the shape interacts with its surrounding space shape.

▸ Varying the width to avoid same-width dullness.

Evaluate dark shapes and adjust them for interest

This edge has a boring, predictable curve. There is very little excitement along the edge to integrate it with the surrounding space.

Draw the Shape and Identify Any Problems

Now draw the dark shape. When you do so, you should notice one very big problem with it.

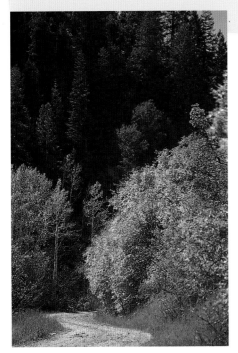

Stare to Avoid Details

Stare at the dark shape in this photo until the detail disappears and you see it only as a shape.

Push a light tree shape up into the dark shape to change its configuration.

Vary width of negative space by narrowing it considerably here, then spreading it out at the base.

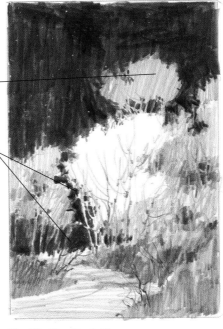

Modify the Dark Shape

Varying the width of the predictable curve and creating interaction with the surrounding space shape enhance the composition.

Finished Painting

Most people who see this painting comment on the color, but it is really the dark shape carving out the light shape that gives it visual impact. Without changing the shape, you would only have a colorful boring shape.

AUTUMN WALK ▸ Watercolor ▸ 21" × 14" (53cm × 36cm)

See multiple shapes as one shape of similar value

Simplify the numerous items by uniting them into one shape of similar value.

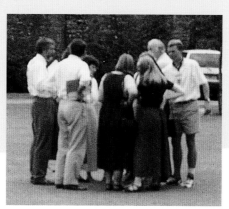

Reference Photo
If the enemy within were in charge of painting this group of people, you would outline each figure and color them in, clearly distinguishing each person. But that is not the way you see. Look at this group. Your artist's brain actually sees only a few shapes of light and dark.

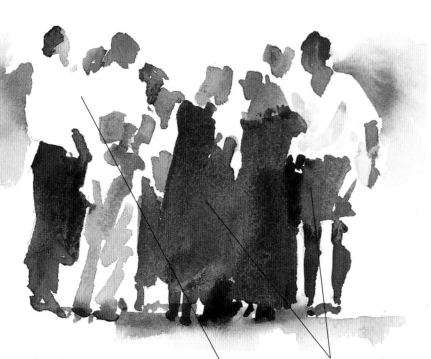

A Watercolor Sketch of Lights and Darks
This is not just a clever way to paint the group; it's a painting of the actual pattern of lights and darks that entered our brain as we saw the scene. Our eyes fill in the detail we don't see. If you get these larger value shapes right, the viewer will fill in the detail.

These white shirts and light on pants blend together into one white shape.

One shape of dark encompasses at least three dresses, a pair of shorts and legs.

Practice Many Watercolor Sketches
Paint some single figures and groups of figures. Eliminate the boundaries between items and concentrate on keeping the similar values flowing together into one shape.

Reference Photo

If we started naming all the things in this photo—signs, people, buildings, shadows and so on—we would soon get discouraged by the complexity. Instead, squint your eyes to see the larger shapes of value. These shapes are easier to draw and paint, and they are more visually accurate than the enemy within's version of the items would be.

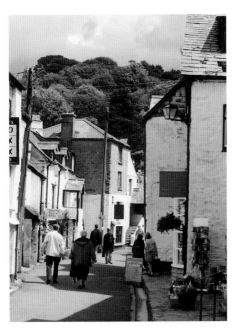

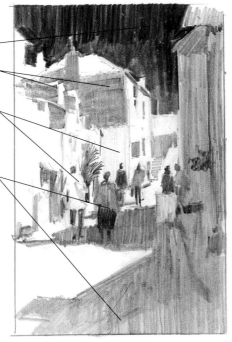

Dark shape of space

Middle-dark shape of connected shadows

Large shape of connected lights

Large shape of merged middle-darks

Find Big Shapes of Similar Value

If we look for the large shapes of value, we discover there are only a few. The area on the right along with the figures and the shadow on the ground become part of one huge shape of middle-dark value. The dark figures merge with the larger shape when we squint.

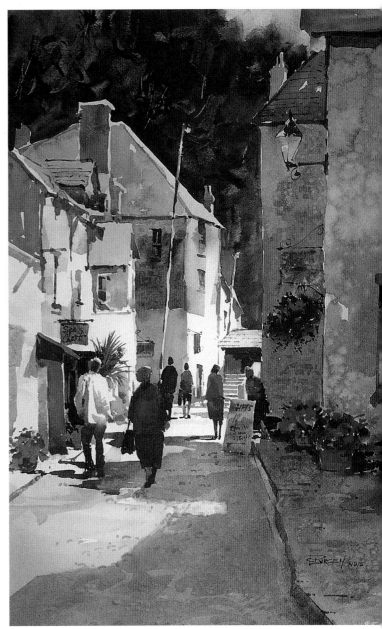

Finished Painting

Exercising the practice of seeing large, simple value shapes helped me to switch into shape mode for this painting. Notice the considerable range of color within the value shape. However, when you squint you will find the value of the shape does not change. This preserves the integrity of the shape. It is the value that builds a shape, not the color.

SHOPPING IN POLPERRO ▸ Watercolor ▸ 21" × 14" (53cm × 36cm)

81

Use shapes of light to create visual paths and bridges

Artist Gerald Brommer correctly observed that, "The eye moves most easily along pathways of similar value." If you have to jump from one place to another, you will naturally stop first and plan your jump. Your eye will do the same. If no bridge is provided, it will stop, then jump. Keep the viewer's eye moving until it gets to the center of interest.

Shapes of light have the same ability as dark shapes to connect areas of your composition and provide a visual path for the viewer. Provide a bridge from one shape of light to the next to create whole shapes of light value. And remember this: A good light shape without a dark shape to go with it is no more effective than a flashlight at noon in the Sahara.

A well-placed blossom connects the upper and lower flowers, creating one large interesting shape out of all the blossoms. This light shape can now play opposite the large dark shape moving down from the top.

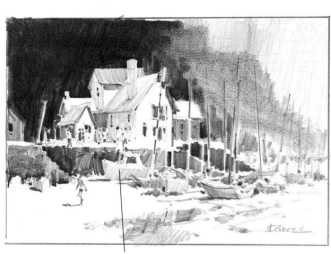

This white boat provides a bridge from the white sand shape to the white building. We now have one big shape that provides a pathway for the viewer.

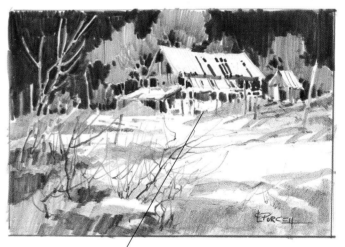

This vague white shape provides a bridge from the white foreground shape to the white of the barn roof. It doesn't have to be a specific thing, just light in value.

In the reference photo for this scene, the entire barn appeared in shadow. The light on the barn added in this sketch provides a good center of interest.

Reference Photo

In this case, there is too much of the light value and it is divided into two separate shapes. The light shapes should be interesting and lead the viewer's eye to the center of interest.

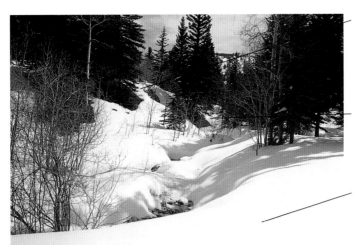

This point of the light shape heads off to its own destination. It needs redesigning to lead to the center of interest.

This part of the light shape leads into the center of interest, which aids the composition.

This light shape is boring and cut off from the others. It leads into the corner instead of to the center of interest.

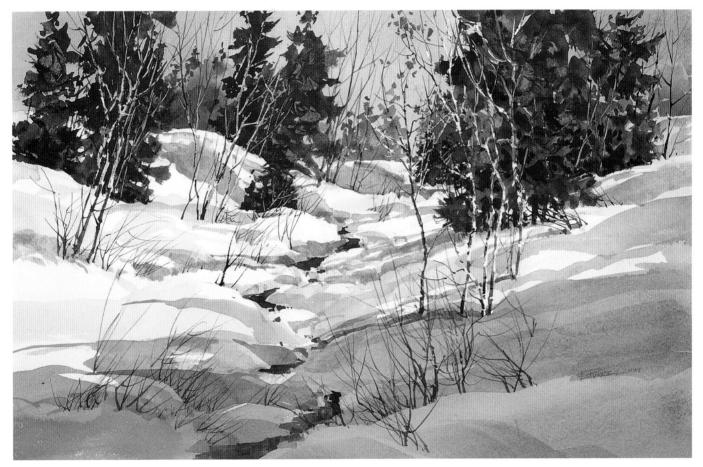

Finished Painting

The large tree shape was broken up among the light shapes to enhance their interest and lead the viewer's eye into the center of interest. I expanded some darker values to the ends of the format to diversify the foreground light shapes. The stream also breaks up the foreground and provides a bridge to the center of interest.

SHADOW PATTERNS ▶ Watercolor ▶ 14" × 21" (36cm × 53cm)

Seek Good Values, Not Great Subjects

If you look for interesting light or dark shapes instead of looking for interesting subjects, you will be on your way to creating stronger paintings.

Develop a better
LIGHT SHape

materials

PAPER
Arches 140-lb.
(300gsm) rough

BRUSHES
Nos. 8 and 12 rounds
1-inch (25mm) flat

WATERCOLORS
Carbazole Violet
Manganese Blue
Quinacridone
Burnt Orange
Quinacridone Gold
Quinacridone Rose
Quinacridone Sienna
Sap Green
Ultramarine Blue

OTHER
6B pencil
Sketchbook
Palette knife
Paper towels
No. 60 grit sandpaper

You will rarely find the perfect composition. In every subject good dark shapes are found alongside boring light shapes, great linear motifs are mixed in with lines leading out of the picture, or you will find great shapes but with the value contrast in the wrong place. It is your job to paint it ideally. Vincent van Gogh said that artists should not paint what they see, but what they feel.

Follow along as I make a number of changes for a better composition in this demonstration, specifically a better light shape.

Reference Photo
Evaluate the strengths and weaknesses of the shapes and other motifs in this subject.

A well-placed light shape, but too small. It needs to be connected to the light shapes at the bottom. This shape is the key to a better composition.

This is a great pair of dark shapes connected by a narrow bridge.

Good light linear motifs break up the dark shape.

A boring shape of lighter foliage

Isolated light shapes—too separated from the other light shape

WATERCOLOR DEMONSTRATION

Carry the light shape to the bottom of the dark shapes. Narrow the light shape by having the darks nearly touch. This adds variety to the shape.

Position the foreground light (the stream) so it enters at a diagonal and then turns towards the "bridge," but not too swiftly.

Solve Problems With a Value Sketch
The greatest problem here is that there is no bridge between the light values. I redesigned the foreground to provide one.

These linear motifs, both dark and light, are lovely—keep them.

Make this shape more interesting.

Bridge the light shape of the sky and the light shape of foreground water.

Create a dark shape of grasses to define the light shape of the water.

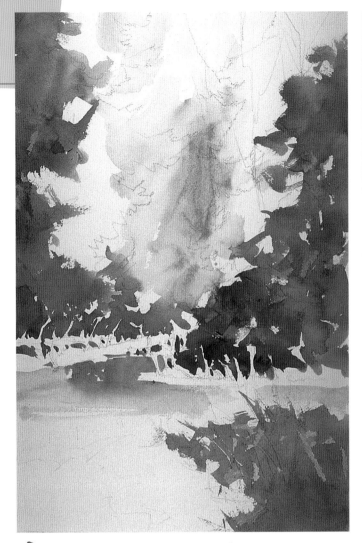

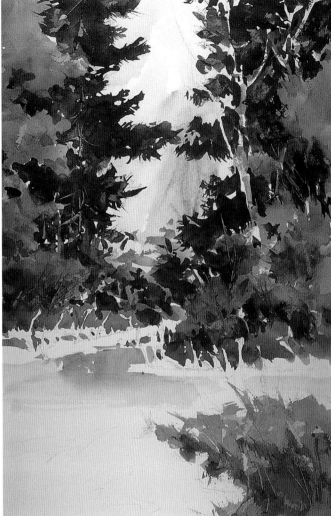

1 Establish the Middle Values

Transfer your plan to watercolor paper, and complete this entire first step with a 1-inch (25mm) flat. Create a fluid wash of middle-value colors, letting them mingle on the paper. Start at the upper left, changing from Sap Green and Manganese Blue to Quinacridone Sienna. Change colors but not values each time you reload your brush. Paint around the lines that will become limbs on fallen logs at the bottom of this mass. Add some middle-value forest colors in the center area using Manganese Blue and Quinacridone Rose.

Begin the upper right with Carbazole Violet and gradually add Quinacridone Sienna. Bring in some Quinacridone Gold and Sap Green in the middle area. Leave plenty of sparkling whites—some will become part of the light trees. While the wash is still wet, drop in Quinacridone Sienna at the base of this mass to help establish the center of interest. Let the colors mix on the paper. End the mass with whites for log branches.

Repeat some of the same colors for the water reflections below the fallen logs. Rinse the brush and grade out the color to white paper. Create the grasses in the lower right by loosely brushing Sap Green and Quinacridone Sienna.

2 Build the Dominant Dark Mass

Begin in the upper left with a mix of Sap Green and Quinacridone Burnt Orange using a no. 12 round. The only detail necessary is at the edges of the shape. Flip the end of your brush to suggest pine needles. While this dark area is still wet, use a palette knife to scratch a few limbs and to push the paint around a bit. This will provide some lighter textures within the darks.

Continue the dark wash downward, adding some Ultramarine Blue to the green. Numerous greens exist in nature, so don't fall into the one-item-one-color mental trap. Some more scratching with the knife will enliven the wash. Rinse out the brush and soften some edges.

Begin the upper right with the Sap Green and Quinacridone Burnt Orange mixture. Leave some light branches here and there. Soften some edges for variety. Build the narrow bridge between the two dark masses. Bring some of the darks under the bushes where the sun doesn't shine. Add a dark shape to the foreground grasses, then spread it around a bit with a palette knife.

3 Build the Structure for the Water

A few washes will turn the remaining white shape into water. Start with the reflections by wetting the area and floating in a lighter version of the colors used for the foliage above with a no. 12 round. For the birch trunk reflections, paint a couple of vertical strokes onto the wet area with your flat and Quinacridone Sienna.

As you head toward the foreground, leave some white at the edge where the water cascades into the falls, because as the water goes over the edge it reflects the light from the sky, not the trees. Suggest moving water with a few splashy strokes using a no. 12 round and a mix of Ultramarine Blue and Quinacridone Sienna. Drag the brush sideways to create ragged-edged strokes. Add sparkle to the ragged strokes by spattering a small amount of the paint; just tap the brush across your finger.

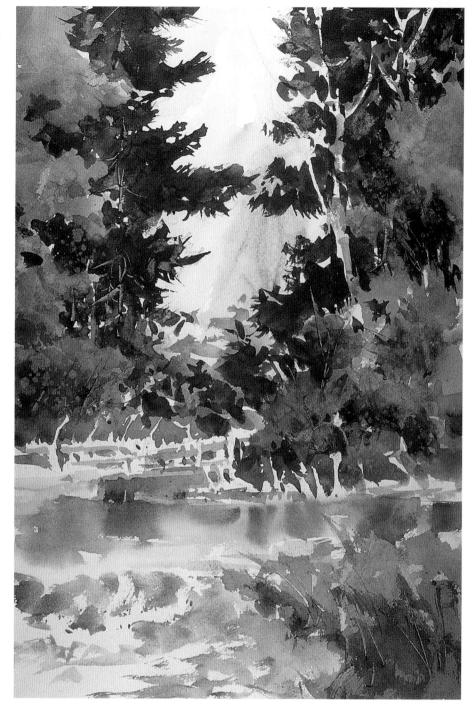

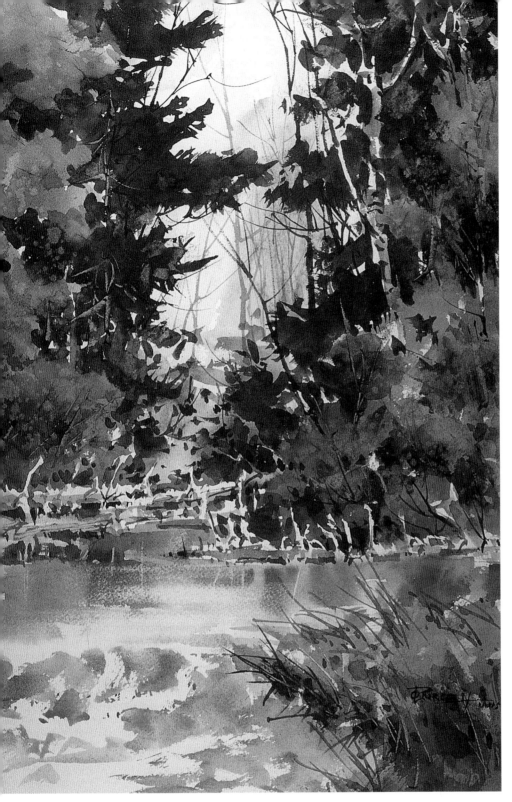

4 Define Some of the Objects With Detail

Completing the painting involves bringing a few things into focus. With a pointed no. 8 round and a light mixture of Carbazole Violet and Quinacridone Burnt Orange, add some calligraphic strokes to the distant trees. Darken the mix with Quinacridone Burnt Orange and add limbs for the closer trees. All of these calligraphic lines add rhythm and life to the central part of the painting while establishing depth.

Add shadow to the fallen logs, switching between Manganese Blue and Quinacridone Sienna. A piece of no. 60 grit sandpaper can add a little sparkle to the surface of the water. Wipe it horizontally across the middle part of the water where the light from the sky would be reflected. Add a few bits of dark and some cast shadows along the riverbank, but not too many. A few calligraphic strokes suggesting bushes and grass complete the painting.

WOODLAND STREAM
Watercolor
21" × 14" (53cm × 36cm)

POINTS TO REMEMBER

- We read shapes by value. The most powerful tool you can cultivate as an artist is the ability to simplify your subject into shapes of value.

- If you get the large shapes right, the viewer will fill in much of the details.

- A good shape is built with value, not color.

- For more impact, connect the light shapes into one large value shape, and do the same with the dark shapes.

- A good light shape needs a good dark shape by its side.

- Do a value study before painting to plan the value shapes.

- Details can only embellish the shapes that are already there. Hang your details on a strong value shape.

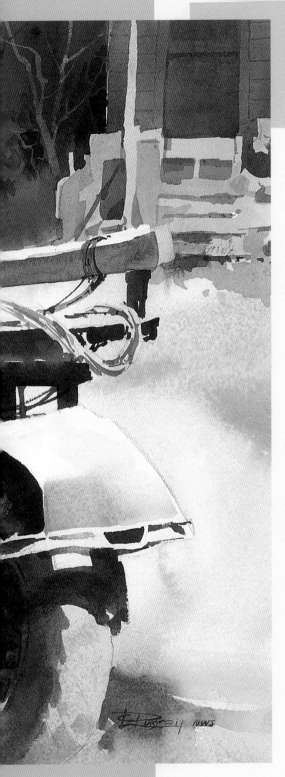

building a painting
on VALUe PaTTeRnS

It is common to be overwhelmed by the many shapes of value that you encounter when looking at a scene. Your intellectual brain wants to separate every single shape and tackle them one at a time. As a result, your painting may have a fragmented or "checkerboard" appearance. However, by using your artist's brain, you can avoid this trap by linking shapes of similar values into a large pattern that touches several edges of your format. This strengthens the composition of the painting. It only took me a decade to learn how powerful this concept is. Master it, and you will be surprised at how well your paintings hang together.

REED THE TINKERER ▸ Watercolor ▸ 14" × 21" (36cm × 53cm)

Value patterns bring order out of chaos

Value patterns can do so much for your paintings, including:

- ▸ Connecting otherwise disparate pieces of similar value into one unified whole

- ▸ Activating the format

- ▸ Leading the viewer's eye through the composition

- ▸ Providing a structure on which to hang your detail

Nothing builds cohesive structure in a painting better than connected patterns of similar values. By bringing all the little pieces of dark value together into one large, connected pattern of dark values, and making that pattern touch several edges of the paper, you will unify and strengthen your composition. For some reason, this concept seems to be the most difficult to learn. Our intellectual brain interferes with the process, demanding that we identify all the things that make up the pattern. And once the enemy within takes over, our paintings are finished.

Values Working Against Each Other
Notice how your eye seems to bounce in this composition. Each of these pieces of dark value is demanding your attention. There is no teamwork or pattern; the movement is completely random.

Values Working Together
Here the same dark shapes, plus a few additions, are unified into one complete pattern. Squint your eyes to see how they are all connected. The viewer's eye is led to the center where the most contrast occurs. This is a good example of harnessing the power of value patterns.

It is important to know how to evaluate the value patterns you see and feel the freedom to make changes. Look at your subject with a critical eye to determine which shapes are working within the composition and which ones are not. Remember, do not identify the items by name. Use your artist's brain to see them as value shapes, then eliminate the shapes that don't work and enhance the ones that do.

As you create value plans like the ones shown on this page, think ahead to other possibilities or variations of the pattern. The most creative question you can ask yourself is, "What would happen if I...?" Squint your eyes to see patterns that exist and to see possibilities in your drawings that don't yet exist.

Practice evaluating value patterns

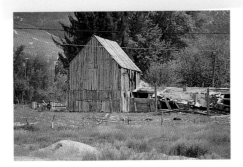

Reference Photo
This rural scene has some good points and, like most scenes, it also has some aspects that could cause chaos.

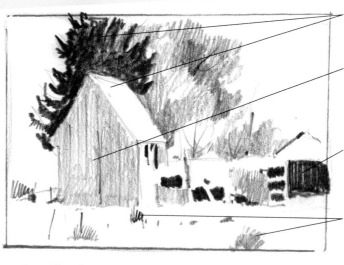

This light shape looks good next to the dark shape.

The shape of the focal point needs some enhancement.

This dark shape is too far from the focal point. It competes for attention.

This foreground shape is too boring and has isolated dark pieces in it.

Analyze Sketch
This drawing of the subject has light, dark and middle values distributed exactly as they appear in the photo.

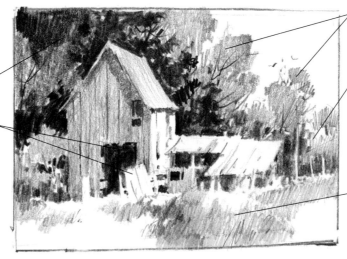

Extend the dark shape to touch the left edge.

This dark shape enhances the focal point. A light shape in front of the dark shape increases visual interest.

Design a middle-value shape to add interest to this shape of space.

Remove the original dark shape on the far right and shorten the shed shapes connected to the main subject. This keeps all the lights near the focal point.

Create a middle-dark value shape for the foreground, which leads the viewer's eye from the bottom to the focal point.

Modify Subject
This is the same subject, but it certainly looks better dressed up in a beautiful value pattern that extends to all edges of the picture plane. Squint your eyes to better see the patterns of dark and light.

Simplify nature's complexity with value patterns

Using your artist's brain to think in terms of value patterns allows you to simplify the dizzying array of things you find in nature. An isolated shape of dark draws attention to itself. If you don't want it to be a center of interest, merge it with a larger pattern of darks. If you can't tie it into a pattern, then get rid of it.

Reference Photo

Every time you evaluate shapes and patterns in a subject, you will find shapes that fit nicely into a coherent whole and those that don't. This scene has a powerful sweeping shape of dark that pulls the viewer's eye across the top part of the format to the light shape of the waterfall. Build around this. The scene also has a series of unconnected darks in the foreground rocks.

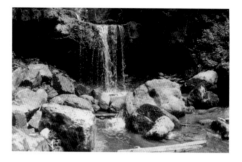

Connect Value With an Initial Sketch

Notice how the pattern moves across the top third of the paper, then turns back across the very top. Now we need to connect it to some values in the foreground. After doing this sketch, I asked myself, "What would happen if I moved the white over to the right, so the viewer's eye travels farther before moving downward?" The answer can be found by doing another rough, five-minute value pattern sketch.

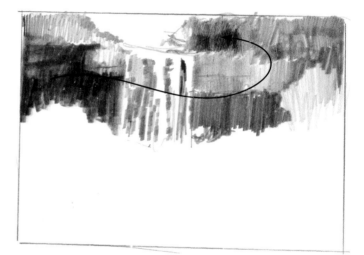

Make Adjustments in a Second Sketch

Switching the location of the white value shifts the emphasis out of the center. Now activate the foreground by adding values to the basic shape. There are probably hundreds of different patterns that would work. Think connected darks, not "this rock and then that rock and then... ."

Compare this final plan to the photo. Notice how much simpler the foreground is. Now there isn't any competition with the center of interest.

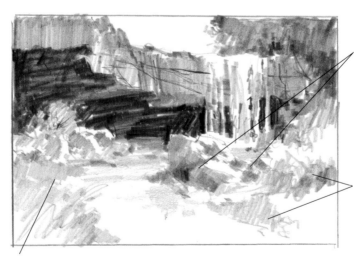

Connect these darks to the darks in the middle-ground rocks. You may have to change the shape of the rocks to make them more interesting. Have them point back up to the main dark shape.

Bring the pattern down to touch the bottom of the paper somewhere other than midway across.

Connect these values into a pattern of varied width leading down to the bottom of the paper. This leaves a pattern of lights moving up from the bottom and over to the main subject.

The color and a few lines will suggest grass. Nothing else is needed here. Keep it simple, especially in the areas farthest from your main area of focus.

Leave some lights for sparkle.

Add color to the darkest darks to prevent them from looking flat.

Scratch out these lights with a knife after the dark is dry.

For variety, change colors but not values as you move along.

Change the color but not the value as you move from dark rock forms to dark foliage. The overall value pattern is more important. Allow the two to flow together wet-into-wet.

Define the planes in the rocks by value.

The water shapes are left by faithfully observing the kind of edge the dark space shapes have. Paint a light bluish wash over most of the whites after the darks have dried.

Suggest form with pattern. Don't try to define everything.

Translating the Sketch Into a Painting

In this case, I may have gone a little too far with the finishing details. But the value plan in which the values were organized into a cohesive pattern saved me from slavishly copying the photo. Most of the time I complete a drawing on location and take a reference photo. Later when I compare the two, I always like the drawing more. I use the photo only for detail reference once I have created the basic painting.

SERENITY FALLS
Watercolor
21" × 24" (53cm × 61cm)

Build a value pattern
in a painting

Keep in mind that the value pattern is the structure that holds a painting together and the details merely entertain. Viewers notice the entertainment, but seldom recognize the pattern holding it all together. That's OK. No one notices your skeleton either, and it holds you together, provides support for all your details and gives you mobility.

In this demonstration, we'll take a rather complicated outdoor scene and simplify it with a value pattern. Once this pattern is in place, we'll add just enough detail to enhance the scene without boring the viewer by spelling everything out.

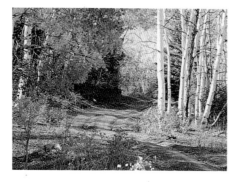

Reference Photo
At first glance this scene may seem perfect for painting, and if you painted it just as it is, it would be passable but not strong. To make the scene stronger, we need to address two problems: (1) The darks are not quite joined into a complete pattern, which gives the composition a slightly disjointed appearance; and (2) The aspen trees on the right beg the enemy within to name and count them. The enemy is afraid that you will lose them, so it wants you to get out the masking fluid and preserve each one from being contaminated by subsequent washes. This intellectual approach separates these lights from the rest of the painting, which will make them difficult to deal with later to create a final unified composition.

WATERCOLOR DEMONSTRATION

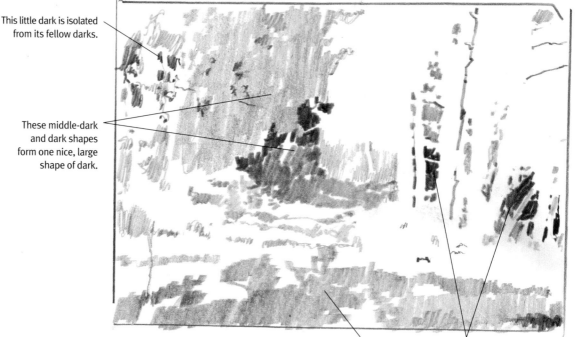

This little dark is isolated from its fellow darks.

These middle-dark and dark shapes form one nice, large shape of dark.

The middle-dark shadow unites the foreground, however, it doesn't connect with the other darks.

These dark shapes are isolated.

Analyze the Values in the Photo
When you really look at the values and not the colors, the problem is evident. This composition suffers from value separation disorder.

Solve Composition Problems

This version of the composition solves the problem and connects the darks. Now they form a complete pattern touching all four sides of the paper.

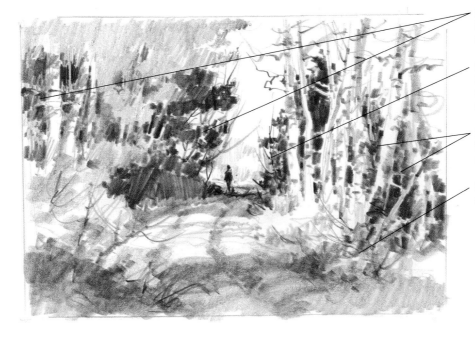

Provide a bridge between these two dark masses.

Bring this dark out from behind the trees to connect the left darks to the right darks.

Continue the darks through the trees to the right side of the paper.

Bridge the foreground darks.

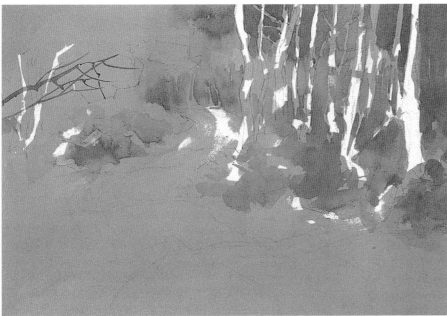

1 Limit the Whites and Create a Mood

Using a 1-inch (25mm) flat, lay in an initial wash with Quinacridone Gold and Aureolin Yellow. This wash limits the whites, creating a warm mood. Don't try to leave every tree intact; this is not what we see. We see pieces of white on various trees. This provides sparkle and visual excitement.

Continue with a no. 12 round. Apply a light wash of Manganese Blue and Quinacridone Rose in the upper right to provide some background for the trees. Change to Quinacridone Sienna and add some foliage patterns near the base of the trees. At this point you are only painting patterns. However, I did add a dark tree limb on the left because I wanted to remember where that point was. This was the same light mix used in the upper right but done with a no. 8 round.

2 Construct the Foundation Pattern

At this stage you are only working in the middle-value range. Block in the general shape of the foliage in the upper left using your flat and Quinacridone Burnt Orange. Paint a light wash of Carbazole Violet across the far end of the road for the shadow. This links the left with the right. Continue painting with Quinacridone Sienna, leaving whites for the trees, to build a midvalue pattern at the base of the trees. Add a touch of Sap Green for variety. Paint the lower left corner slightly darker with a wash of Manganese Blue and Quinacridone Rose.

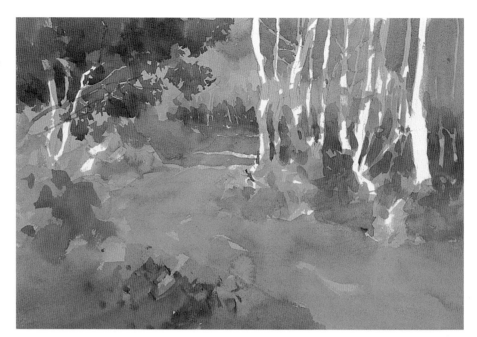

3 Connect the Darks

This step provides punch, ties the painting together and gives sparkle to the whites. Using a no. 12 round, begin at the left with some Carbazole Violet and Quinacridone Burnt Orange. Paint the dark shapes of space, defining a few branches as you go. Add Sap Green as you get to the pine boughs above the road. These darks define the shapes of the lighter foliage. Switch to Quinacridone Burnt Orange for the road.

Add a little Carbazole Violet to Quinacridone Burnt Orange for a darker shadow across the road. Apply Sap Green and a little Quinacridone Sienna for the dark tree shapes behind the white. Scrape out a few limbs with a palette knife while this is still wet. Add more darks at the foot of the trees. Carry a lighter shadow across the road, varying its thickness to suggest ruts. With your flat, add some darks to the lower left and paint the large shadow across the road in the lower right using Manganese Blue and Quinacridone Rose.

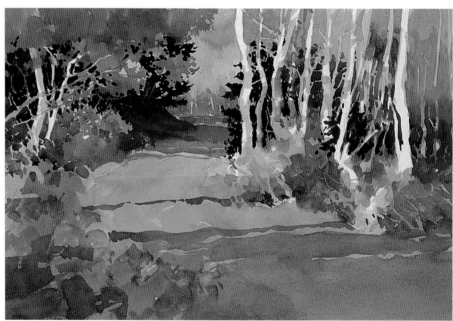

4 Add Final Details

Create a mixture of Quinacridone Rose and a little Manganese Blue. Strike in the shadows along the white tree trunks using a no. 8 round. Shadows crossing the trunks and the dark marks define and complete the trunks. Add a few dark branches with a no. 6 round. Add texture to the road by spattering it with a little water, blotting it and then quickly rubbing it with a paper towel. A figure at the end of the road adds scale and a human touch to the center of interest.

A STROLL FOR THE SOUL ▸ Watercolor ▸ 14" × 21" (36cm × 53cm)

Connect the Darks

Do you remember doing connect-the-dot puzzles as a child? Think of how the picture was revealed after you connected all the dots. Darks in a painting are like that. When they are separated from each other, they fail to show the picture. However, when they are connected, they provide a structural skeleton for the image.

Activate the format using value patterns

One of the most common problems I see when critiquing paintings is a subject painted too small for the format. This results in a lot of uninvolved space. How many times have you resorted to the cropping method of composition? Where you finish a painting and feel as though much of the space around the subject is not needed, so you crop it. You like the painting better after cropping because the subject involves all the space in the format instead of a small area in the center.

Just think of all the time you have spent painting those areas that end up on the cutting room floor. If you plan that space from the beginning, you won't have to cut it off later. I call this concept "activating" your format.

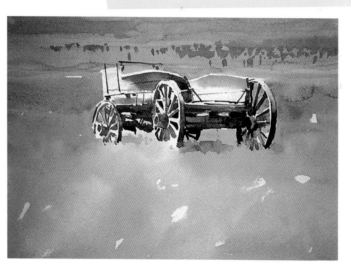

Analyze the Format to Prevent Isolation

Here is a typical presentation of a subject. No matter how well you paint this old wagon, if it floats in the middle of undesigned space, it will suffer from a sense of isolation and loneliness. A psychiatrist might call this separation anxiety.

All the dark values are on the wagon. None touch the edges of the format. They will never activate the format until they get involved with at least one edge of the paper. Do whatever it takes to connect these darks to the format. Only this will prevent isolation and separation anxiety.

Plan the Painting With a Value Study

Use your artist's brain to envision a value pattern that touches the format, embraces the subject and defines the light shapes of the subject with values. Then create a value drawing with the subject and the envisioned pattern. Even though specific objects in this added pattern of values are not defined, you identify what they are just from their context. Remember, detail doesn't do this.

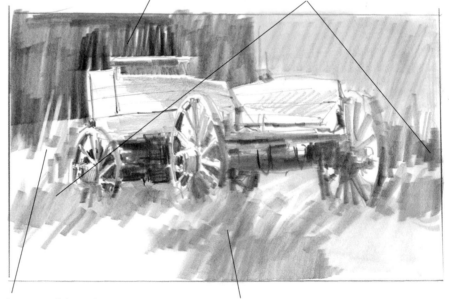

Place a large area of dark behind the light part of the subject.

Continue the darks from the subject to the edge of the paper.

Leave some lights to tie the light of the subject to the space around it.

Create a dark shape with variety in width that will connect the subject to the bottom of the paper.

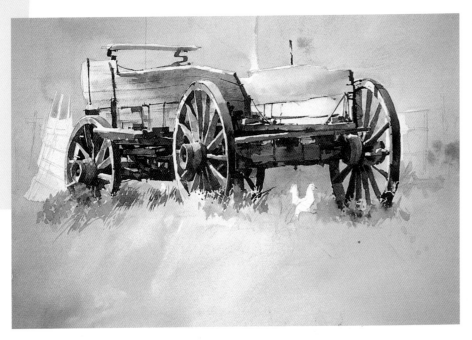

An Improved Composition, But it Still Needs Help

Even when painted larger within the format, the wagon still seems lost and disconnected— decapitated, like a portrait without the neck. It needs to reach the edges of the format.

Keep the detail well within the value range of darks. When you squint, the details should almost disappear.

Flood rich colors into the shadows and avoid flat, ugly darks.

Provide a little value contrast in the sky to define the side of the wagon. Light shapes need darker value to define them.

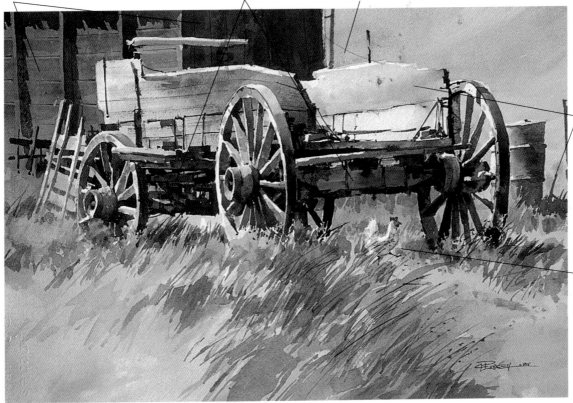

Repeat colors around the format. These spots of blue balance each other. Blue is also found in several areas on the wagon.

The chicken was an afterthought. I had some white there and the idea suggested itself.

A Better Composition

Compare this revised painting with the first one in which the subject is isolated. This is better than cropping because it has a sense of having been planned this way from the start. Squint and see how the value pattern activates the format. No isolation and loneliness here. A simple value pattern can reduce the need for detail and simplify the painting process, making the painting stronger.

No Horse Power ▸ Watercolor ▸ 14" × 21" (36cm × 53cm)

Develop your sense of value pattern

Learning to work and think within a format is essential to painting. Some people start painting and keep on painting until they simply run out of canvas or paper. If they end up with a decent composition, it is sheer luck or a miracle.

The following exercises will help you develop the ability to see value patterns. Your goal in these exercises is to create a pattern of darks that:

▶ Aesthetically divides the format by touching at least three edges

▶ Interacts with its surrounding space

▶ Has variety in width

Use pieces of white mat board or watercolor paper cut to about 6" × 8" (15cm × 20cm), a 1-inch (25mm) flat and any tube of dark color.

Pattern touches three sides of the format

Skinny in places

Very wide in this area

Many places along the edge where pattern and space interact

Pattern touches three sides of the format

Paint a Pattern With Variety

Load your brush with a dark color, such as a mixture of Carbazole Violet and Quinacridone Burnt Orange. Keep it neutral rather than a pure bright color so you can focus on the shapes. Begin on one side of the format, but avoid the midpoint. Build a pattern by painting one stroke after another. Keep the strokes clean by resisting the urge to go over each stroke again; just touch the edge of the previous stroke. Connect the shapes until you reach the opposite edge.

Build as much variety as possible into the width of the pattern, from very thin to very wide. (A flat brush will encourage you to do this more than a smaller brush.) After you reach the opposite side, go back to a point near the middle and continue the pattern to the top or bottom.

Discover Aspects to Avoid

Avoid making a boring pattern like this. Although the strokes are connected and the pattern reaches the edges of the format, notice that each stroke is nearly identical, making the resulting pattern basically the same width throughout. It also divides the format into four equal parts; the four shapes of space are almost identical.

Play With Different Patterns

Try creating a pattern that touches most or all of one edge of the format.

Value Pattern With Three Values

After you have practiced this exercise and have achieved some interesting results, try some with an intermediate value. The previous exercise utilized two values—dark and light. In this version start with a middle value, limiting the whites to a connected pattern. Then add a pattern of darks. The result will be dark and light patterns on a midtone background.

Middle-Value Beginning

This three-value pattern began with a gray wash of Manganese Blue, Quinacridone Sienna and a touch of Permanent Rose. I covered the entire format except for a T-shaped pattern of whites.

Bring On the Darks

Next, I used a neutral dark to build a pattern that touches three sides of the format. Many of the darks were placed directly beside the whites. This produces a very dramatic pattern.

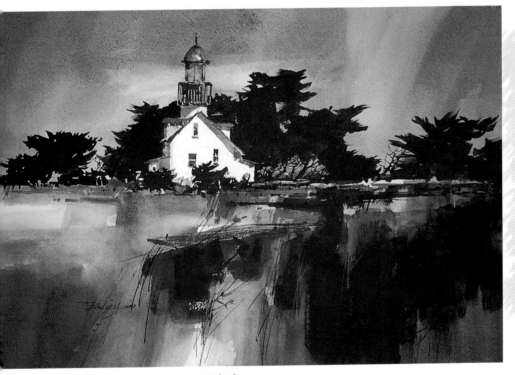

A Value Pattern Becomes a Painting

Every now and then, one of my random value pattern exercises begs to be turned into a serious painting. Such was the case with this one. It just seemed to suggest a landscape with its emphasis on the horizontal. The white shape near the center suggested a building. I decided to use this pattern as the basis for a painting, using a drawing I had done of Point Pinos on the Monterey, California, peninsula. With just a little adaptation, it produced a dramatic painting.

During the course of these exercises, you too may produce a piece so good that you will want to make a painting of it. If you just use the small exercise as a guide and create a similar pattern, you could simply leave it as an abstract piece. Who knows, it could win a prize at your local art show.

LIGHTHOUSE ▸ Watercolor ▸ 14" × 21" (36cm × 53cm)

Find Cheap Paper for Exercises

If you cut your own mats for your paintings, you will have odd pieces of mat board left over. Save them and cut them up. It doesn't matter what color they are, because the back is always white. If you have none, your local frame shop will probably save you the center cuts that are too small for them to work with.

Another option is to use the backs of old paintings that didn't quite make it. If you are like me, you have plenty lying around.

Find interesting value patterns in your photos

I take several types of photos with my camera. Some are of interesting shapes that I might use in painting, some are of value patterns and others are references of details. Then there are the ones my wife Nan reminds me to take of the children and grandchildren. All of these photos are good sources for value patterns. When taking them, I am looking at the people and other subjects, never noticing the distribution of darks or lights.

Flip through your latest collection photos, and squint as you do. You will spot some interesting value patterns. Try looking at the photos upside down to elude the enemy within; this will help you see shapes of value instead of items.

The following exercise trains your eye to see value patterns in everything; however, the results are not something you will frame and display. Follow these instructions:

1. Tape a half sheet of paper to a board and divide it into fourths with strips of 1-inch (25mm) masking tape.

2. Select a photo.

3. Paint the pattern of darks using a 1-inch (25mm) flat loaded with a neutral dark color. A smaller brush will lead you into painting little details rather than large patterns. You may find it helpful to turn the photo upside down so you do not get involved with the images of the things you recognize, only with what the pattern looks like.

4. After painting the dark pattern, use a light version of the same color and paint everything but the lightest lights.

Here are a few examples to show you what you should strive for. Remember, you are not trying to paint the picture. By practicing these types of exercises, seeing value patterns will become a natural way to think.

Reference Photo
Can you see the large dark pattern when you squint? It moves up the left side of the picture, crosses over, then touches the top before going to the right side. A part also connects up through the center area. This is our subject, not the child.

Value Pattern
Paint the dark pattern, then add the middle values while leaving the whites. Resist the temptation to paint individual features. If you start painting an eye or a hand, your thinking will shift from visual to intellectual and the enemy within will take over. Keep focused on the pattern.

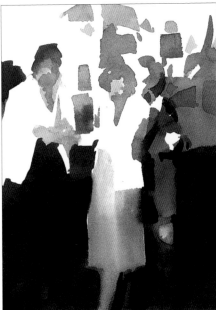

Reference Photo

This photo consists of a large dark shape that moves into gray, then into white as it moves up the composition. See how the whites trickle down into the dark. This value interaction is interesting to the eye.

Value Pattern

Once again, begin with the dark, then add the middle value and leave the whites. Do it with as few strokes as possible. The interaction of white, gray and dark is pleasing to look at.

Reference Photo

This pattern of darks covers the entire width of the top of the picture, then it cascades downward, becoming progressively narrower until it finally touches the bottom in one spot. Seeing this kind of pattern requires much squinting.

Value Pattern

As you paint this pattern, the tendency to delineate each flower and not see its value is overwhelming. Stay focused on the pattern. Squint to see what the dark value does and paint that.

Develop found patterns

Have you ever suffered from painter's block, when even drawing doesn't seem to give you any new ideas? This next exercise in seeing value patterns is a good way to break loose with a little abstract painting. Prepare to have some fun with this one.

You will need two L-shaped pieces of mat board to use as a cropping tool, a 6B pencil and a magazine filled with pictures. Turn the magazine upside down. Scan the pages for photos that have shapes of white, a medium value and black all within the same area. It can be just a very small part of the photo. When you see such an area, place the cropping tool around it, overlapping the L-shaped mat board pieces to form an adjustable rectangle. Adjust the tool until you find a pattern of dark values that activates the format by touching several sides of the cropping tool. Squint your eyes as you do this; it makes seeing the pattern much easier and keeps you from becoming involved with the subject of the photo.

Finding these patterns, even if you choose not to sketch or paint them, increases your conscious awareness of them and fills your subconscious with value pattern possibilities. These possibilities will surface when you need them later. Practice this exercise for a few minutes every day.

On the opposite page, see how you can take this one step further to develop a finished painting from a found pattern.

A Word About Copyright

Use photos from magazines for practice exercises only. Developing a finished painting from someone else's photo may infringe on copyright laws. I have found that sports and news photos are excellent for this exercise. This exercise can be done just as well with your own reference photos if you think you may eventually want to develop a finished painting from one.

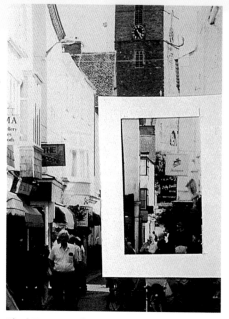

Find Patterns in a Photo

With the cropping tool, search for an area on the photo that contains dark, medium and light values. Hold the photo upside down to focus on the patterns rather than the subject. Look at the cropped section shown above until you only see darks and lights. The dark pattern moves across the top of our format and downward, finally touching the bottom just right of center.

Make a Value Sketch of the Found Pattern

Use a 6B pencil so you can easily achieve the full range of values. Begin with the dark pattern, and then add the medium value. Respond to what is happening in the drawing. The photo is just a jumping-off point, not the desired end. Something quite different, not found in the photo, may suggest itself to you. Be prepared to respond to it; be flexible.

When you finish you should be able to see the relationship between the drawing and the section of the photo, but it should not look like an exact duplication of the photo since you are only drawing the pattern.

Find Value Patterns

Crop to a section that has an interesting value pattern. This section has light, medium and dark values that create interesting shapes.

Draw the Patterns

Make any changes you feel inclined to make. Do not allow yourself to be a slave to the photo. Artists are creators, not copyists. After you establish the initial patterns, look at the drawing for inspiration, not at the photo.

Reference Photo

The value pattern we discover in this photo will become a finished painting.

Establish Color Dominance

Put the photo away and use the drawing as your reference for the painting. Indicate the position of the lights with a pencil drawing. Lay in a varied strip of color across the top one-fourth of the painting using a mixture of Manganese Blue and Ultramarine Blue and a 2-inch (51mm) brush. This will be the secondary cool color.

Paint the medium values in the lower three-fourths of the painting using a combination of Quinacridone Gold and Quinacridone Sienna. Leave the whites. This establishes a warm dominance for the painting.

Add Final Details

Begin laying in the dark pattern, breaking up the middle values with darker variations of the warm colors. Create the darks with Quinacridone Burnt Orange and Carbazole Violet. Follow your instincts as much as the drawing. Let each stroke suggest the next.

Whenever I start a painting like this, I have no idea what the finished piece will look like. I have only a value pattern as a start, and an exciting journey of discovery ahead. Embrace the fear of not knowing each step ahead of time.

PRELUDE IN ORANGE ▸ Watercolor ▸ 10" × 14" (25cm × 36cm)

Create value patterns through doodles

Have you ever just started scribbling some lines on a piece of paper, then absentmindedly filled in the resulting spaces with alternating dark and gray values? Of course you have. I have never talked with anyone who hasn't admitted to having done some of these doodles while chatting on the phone or enduring a boring lecture.

These doodles can be an avenue for exploring value pattern compositions. Usually, doodling is a random, undirected kind of visual playfulness. You can harness this playfulness to develop your sense of compositional design. Create pages of these doodles. They don't take very long, they're fun and they remind you to think of patterns since there is no subject matter to distract you.

You can doodle anywhere and need no special equipment. A pencil or ballpoint pen and notebook are just as effective as Conté crayon and expensive drawing paper. We all have to attend meetings or wait for appointments. These are excellent opportunities to practice your pattern-making skills. Carry a small pad of paper with you and plan to enjoy your next meeting for a change. You should be able to doodle and listen to what is going on at the same time, since these two activities use the two different hemispheres of the brain.

Remember to let the initial lines act as a guide only. These are meant to help free you from the slavery of copying. Don't let the very lines you create enslave you.

Divide a Format With Scribbled Lines
Begin by scribbling a dividing line across a small format, about 2" x 3" (5cm x 8cm). Make it dance before it gets to the other side.

Add a Second Line
Add another line doing roughly the same dance, but overlap the first line.

Create Interesting Space
Add more lines; some that cross the first lines diagonally and others that build on the first direction. You now have an interesting spatial division with a dominant linear direction.

Add Values
Add values to the shapes created by the overlapping lines. Watch the value pattern as it emerges and add to it whatever you feel is necessary. Add light gray to some of the large negative shapes. You now have a value pattern broken up with light that touches all four sides of the format.

Variation 1

So far you have confined the value pattern to the spaces within the lines we generated. Now try giving yourself some specific directions about the value pattern itself. Begin with a large dark area on the left and let it trickle to a narrow shape as it touches the other side.

Variation 2

Now try this concept again, but make an entire side dark.

Variation 3

Or, make the entire top dark and gradually decrease its width as it nears the bottom.

Variation 4

Try confining the pattern within the middle of the format, allowing it to escape just enough to touch an edge or two.

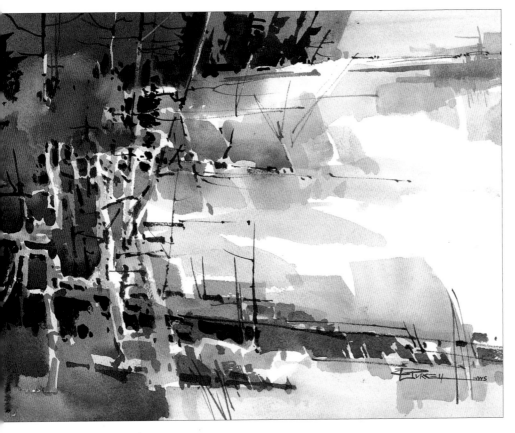

A Doodled Beginning, a Painted Ending

Can you tell that I used the first variation as the basis for this painting? Using your doodles as the basis of paintings will lead to some more daring compositions and possibly an entirely different approach to painting.

ONE CRISP AUTUMN DAY
Watercolor
10" × 14" (25cm × 36cm)

Let value patterns direct visual movement

In the early seventeenth century, Italian artist Michelangelo Merisi da Caravaggio recognized the power of values and their ability to organize visual space. He created emotionally dynamic paintings by using an essentially dark background contrasted with patterns of light that lead the viewer through the composition.

Visual movement around the format is no accident, and must be planned by the artist. It can be accomplished through the use of line and color transitions, but the most compelling method for directing the eye is value juxtapositions. Our eyes move easily from one piece of dark to another connected dark, or from one passage of light to another closely positioned light.

These connected value patterns are your most powerful tool for leading the viewer's eye around the composition. You can use value contrast to plan where you want the viewer's eye to pause, change direction and eventually end up.

Most often your eye enters a painting at the bottom edge. Use patterns of light and dark to lead the viewer's eye from this point in a not-too-direct route to the center of interest. There are no special rules here; just don't make the route so obvious that the viewer is bored or reaches the center of interest too directly.

Vary Value Pattern Paths

This painting has two patterns of value, one light and one dark. Each leads the viewer's eye by a different route to the center of interest: the barn. The lights move from the lower left in a zigzag route like an "S" back to the center of interest. The darks begin at the bottom center and move diagonally to the left then back to the right, encircling the center of interest.

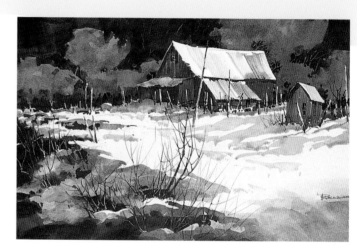

SNOWBOUND FARM
Watercolor
21" × 24" (53cm × 61cm)

Create a Circular Value Pattern

The visual idea here was a pathway of light leading to the light shape of the lake, which is encircled by a pattern of darks. The foreground darks in the grasses connect to the darks in the rocks, which in turn link up with the darks at the far side of the lake, carrying the viewer's eye across to the tree mass on the right side. This is not the way the scene really looked, but this is how I altered it to make a better painting.

LITTLE MOLAS LAKE
Watercolor
14" × 21" (36cm × 53cm)

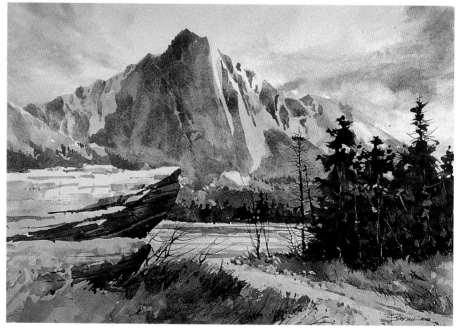

Grab the viewer's attention with value patterns

Spend time planning value patterns for your paintings, and your paintings will be stronger as a result. People may praise them for the details you included, even if there is less detail than you have ever used before. Smile and thank them. Don't try to explain that it is really the value pattern that does the trick. If by chance someone does mention the value pattern, that person will likely be another artist.

The intellect notices details, but the emotional impact of a painting is carried by its value pattern. People will see it without recognizing it, respond to the pattern emotionally without noticing it. Value patterns grab viewers and pull them into the painting. Then their intellect says, "Wow! Look at those pine trees," or "He sure can paint rocks." They literally do not know what hit them. And that's fine; they don't need to. But you, as the artist making the picture, need to know.

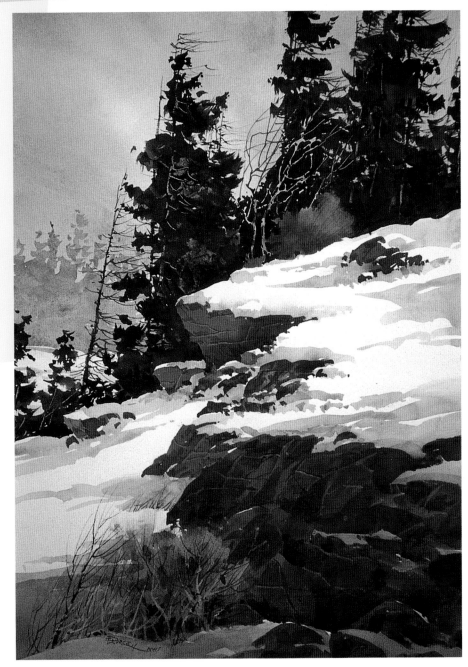

Use S-Shaped Values to Easily Guide the Viewer's Eye

Both the light and the dark patterns lead the viewer's eye in a serpentine or S-shaped movement to the upper central area. The reference photo I took on that cold day in the mountains contained only a couple of rocks in the snow. I grew them into a continuous ledge of rocks.

EXPOSED LEDGES
Watercolor
21" × 14" (53cm × 36cm)

POINTS TO ReMEMBeR

- Value patterns are the skeletal structure of your paintings.
- The viewer's eye tends to move along connected shapes of similar value.
- The ability to see value patterns can be developed through exercises.
- A simple value pattern reduces the need for detail.
- If you can't link a shape to others of similar value, get rid of it.
- Details entertain, but value patterns hold a painting together.
- Value patterns can activate the format.

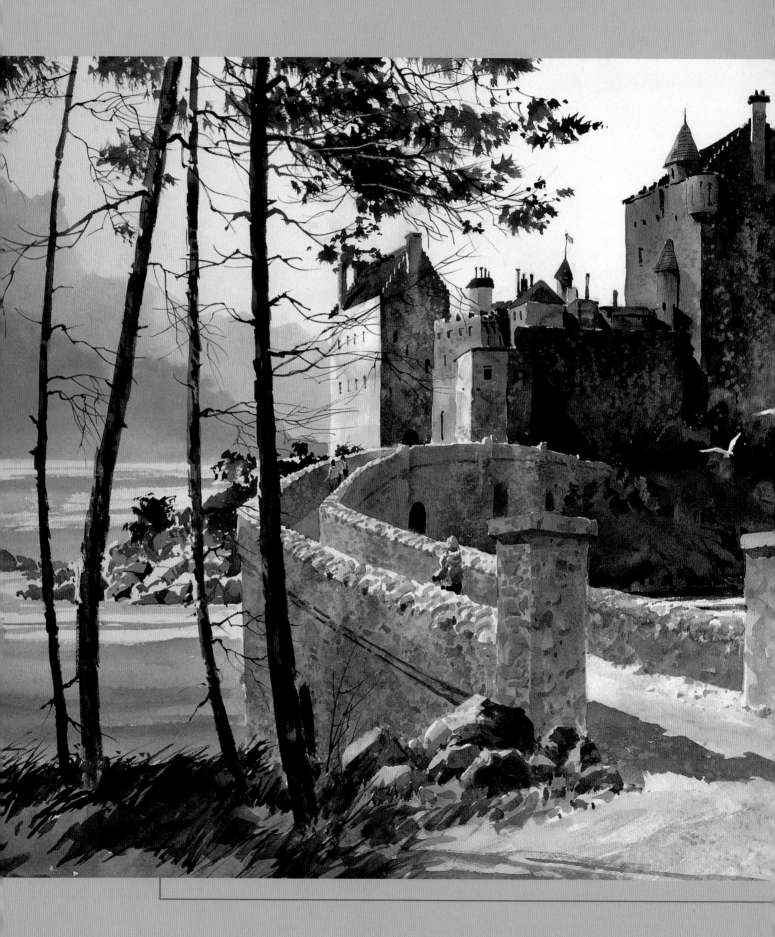

ensuring a strong
CENTER OF INTEREST

When I was a youngster, my cousins and I used to go out into the hills to play with our bows and arrows. I had a cousin who would never say beforehand what it was he was shooting at. He would wait to see what his arrow hit and then claim that was what he meant to hit. In painting, like target practice, we need to know what we are aiming at.

Ask yourself at the very beginning what you want to say in your painting. Be very specific and phrase it in visual terms. For example, the red shape; the white area surrounded by dark, and the dark shape of trees where the river shape meets the base of the hill. This is a crucial step. You cannot design the painting to support the center of interest if there is no center of interest.

EILEAN DONAN, MONARCH OF SCOTLAND ▸ Watercolor ▸ 22" × 30" (56cm × 76cm)

Four methods for establishing a center of interest

Some substitute the term "focal point" for "center of interest." The only objection I have to the former term is that it seems to suggest a small point when the center of interest is usually a larger area. Once you have chosen a center of interest, you must decide two things:

1. Where you will place it in the format

2. The methods you will use to direct attention to it

Just wanting an area to be the center of interest will not make it happen. There are several tried-and-true methods that artists use to add emphasis to a center of interest. Among these are:

- ▶ Value contrast

- ▶ Color contrast

- ▶ Major lines of motion

- ▶ Contrast of complexity

More often than not, an artist will use at least three of the four to ensure that the viewer does not miss the point. Study some of your favorite paintings to see if this is not so. In the center of interest you will usually find the darkest and the lightest values placed next to each other, the area of richest color, and the greatest concentration of small shapes.

In addition, you will find that lines of motion in the foreground lead to the center of interest. The outlying areas will be large and simple, painted in grayed or neutral colors with no strong contrast of values and little detail. What you do not include in the supporting areas is just as important as what you do include in the center of interest.

In the next few pages we will examine these methods more closely.

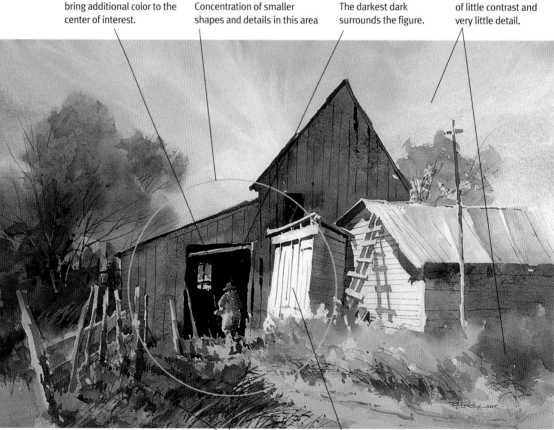

Blue and red on the figure bring additional color to the center of interest.

Center of interest
Concentration of smaller shapes and details in this area

The darkest dark surrounds the figure.

These are simple areas of little contrast and very little detail.

Modify Subjects to Create a Center of Interest
The dark doorway in this scene caught my eye. I decided that if I pumped its interest level up a few notches, it would make a good center of interest. So, I put a light window shape within the doorway, moved the light-valued shed closer to it, and included a figure as a light shape cutting into the dark. Now you can't miss it!

MORNING CHORES
Watercolor
14" × 21"
(36cm × 53cm)

Lines of motion lead to the center of interest.

The lightest light is next to the darkest shape.

Of the four methods for establishing a center of interest, value contrast is the most compelling to the viewer's eye. Design your center of interest as either a light shape surrounded by dark or a dark shape surrounded by light. Plan the remaining areas as middle or midtone values. Placing the strongest value contrast in your center of interest elevates it to a position of eye-catching importance.

A light wash over this shape lessens the competition for attention.

Complementary orange brings even more attention here.

Center of interest

Dark shapes within the light shape accentuate the center of interest.

This white shape is surrounded by dark values.

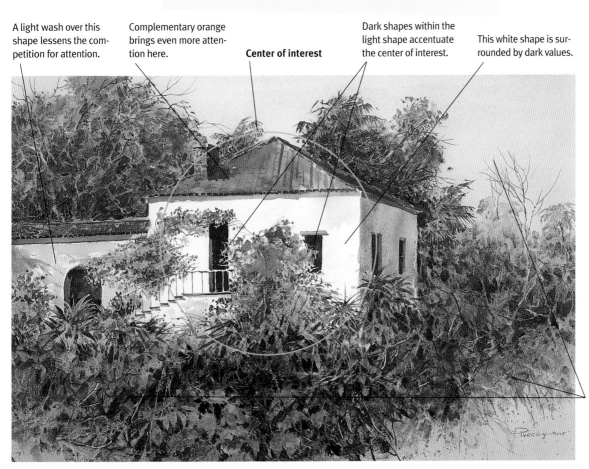

No contrast is included in these areas to avoid competing with the main attraction.

A Light Against Dark Distinguishes the Center of Interest

The center of interest here is a light area surrounded by darker values. Limit the whites to the facade of the building and you will give greater importance to that area of the painting. The strong contrast of white against dark pulls the viewer's eye to this area. The contrasting orange only adds to it, like an extra nail in board.

EL MOLINO VIEJO ▸ Watercolor and collage ▸ 14" × 21" (36cm × 53cm)

Think Value First, Then Color

Beginning artists often think the solution to a dull painting is to simply add more vivid colors. But if your values are poorly planned, no amount of beautiful color will fix your painting. Good color is key to the success of any painting, but a well-executed value plan is what will captivate your viewers.

Engage the viewer with color contrast

Color contrasts are abundant in nature. This is where our ideas about color harmonies originate. Nature provides us with large areas of subdued color (e.g. skies, fields and forests) juxtaposed with small areas of intense, rich color (e.g. flowers, birds and insects). Create color contrasts using all the color properties: warm against cool, intense against muted, and light against dark. Look at a color wheel and notice how complementary colors—those opposite each other—are also opposite in color temperature.

As a rule of thumb, I keep the areas farthest from the center of interest a muted color and reserve the most intense colors for the center of interest. Decide what color is going to dominate the painting, then use the opposite (or complement) in the center of interest.

The value contrast should be most noticeable here: small dark shapes against lights, and light shapes surrounded by darks.

Keep the background simple so the viewer's eye doesn't stay here but rather moves on to the center of interest.

Center of interest
Put the strongest colors in this area. This is the place for the complementary color contrast of red and green.

Warm colors in the upper part of the boat contrast with the cool colors in the lower part and in the water.

Connect the boats with a pattern of dark values that also joins them to the edge of the format.

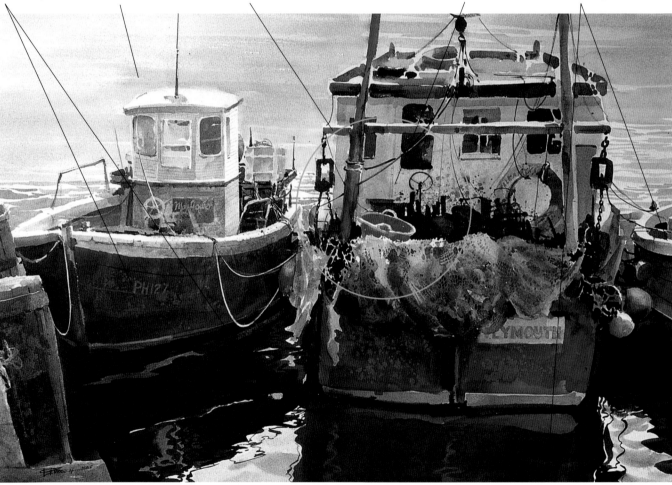

Enhance a Painting With Color Contrast

The contrast of the red-orange bucket next to the green fishing nets drew me into this scene. The contrast of warm colors against cool colors is very appealing. This is primarily a cool painting, with blue dominating the scene. Most of the warm colors are found around the center of interest. Note the yellow storage box, the warm backlit cabin and the buoys. These provide company for the red-orange bucket, since they are all analogous in color. Color may not be able to build a solid foundation for a painting like value can, but it certainly entertains the viewer's eye.

AT REST IN PLYMOUTH ▶ Watercolor ▶ 22" × 28" (56cm × 71cm)

Streams, paths and roads are great tools for providing lines of motion leading to your center of interest. However, use caution with these lines; don't lead the viewer's eye too directly. The shortest possible route may be fine for traveling, but it is not best in a painting.

Direct the viewer's eye in a more indirect route back to the subject by introducing some bends, curves and breaks in the line. The purpose of creating lines of motion is to direct the viewer's eye around the picture plane in a way that allows for exploration, yet keeps leading back to the center of interest. An undeviating movement traps you, and no one likes the feeling of being trapped.

Shapes of shadows, cloud patterns, skylines of distant hills and a myriad of other things with a dominant directional thrust can create lines of motion. Just make sure they are pointing in the direction you want the viewer's eye to go. Choose things to include in your painting based on how they can serve the center of interest. Don't include objects just because they are there. Think of them as actors auditioning for parts in your play. Your job is to create a great production, not provide work for every starving actor. Only use those things necessary for the composition. Send the rest packing.

Follow lines of motion leading to the center of interest

These bushes were actually growing straight up, but I directed their movement toward the center of interest.

Point the sky toward the center of interest.

A transition in value can provide a line of motion.

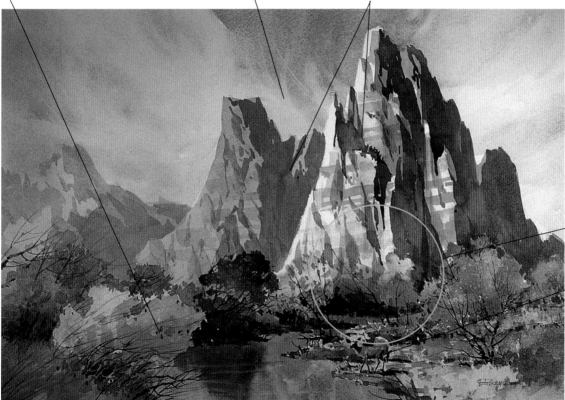

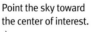

Center of interest
The deer draw the eye to the center of interest.

The edge of the river leads back to the center of interest. Note the many bends and switchbacks along the edge that slow the pace.

Use Natural Lines to Create a Center of Interest
I decided to create a center of interest at the base of the nearest of these three stone "patriarchs." This was mainly because the vertical line of the mountain met the horizontal plane there. I had to move the river so it flowed to that area, creating more color intensity and value contrast.

COURT OF THE PATRIARCHS, ZION CANYON, UTAH ▸ Watercolor ▸ 14" × 22" (36cm × 56cm)

Save visual complexity for the center of interest

The fourth method for developing a center of interest is to have a concentration of color and small shapes of light and dark in the focal area while keeping the surrounding areas as simple as possible. The viewer's eye automatically travels to an area of concentrated energy. We naturally gravitate toward complexity of shape and detail.

The challenge is to consciously simplify areas of the painting that do not contain the center of interest. Decide where you want the center of interest, develop it in your drawing and add shapes to the outlying areas carefully, all the time judging their impact on the center of interest. If they start to compete, get rid of them.

This area is broken up into many small shapes, with more detail than anywhere else.

The center of interest has warm-cool contrasts.

Center of interest
The strongest value contrasts are located in this area.

Lines of motion direct the viewer's eye to the center of interest.

Gradual transition from warm to cool keeps the attention where you want it. A sudden change here would create a competing area.

Simple areas of rest keep the focus where it should be: on the center of interest.

Use All Four Methods to Create a Center of Interest

This painting utilizes all four methods discussed in this chapter. Lines of motion lead from above, below and from the sides to point toward the ancient dwellings. The principal building is the lightest shape and is placed next to some of the darkest darks. The warm colors terminate in the main building, which is set against the cool purples.

Note that the entire group of ruins constitutes a horizontal band of small, complex shapes sandwiched between two wider bands of relative simplicity. This is the visual concept that guides the painting.

ANASAZI INDIAN RUINS ▸ Watercolor ▸ 14" × 21" (36cm × 53cm)

Try a more
SPONTANEOUS PAINTING APPROACH

materials

PAPER
Arches 140-lb.
(300gsm) rough

BRUSHES
No. 8 round
1-inch (25mm) and
2-inch (51mm) flats

WATERCOLORS
Carbazole Violet
Manganese Blue
Opera
Quinacridone Gold
Quinacridone Magenta
Quinacridone Rose
Quinacridone Sienna

OTHER
6B pencil
Hair dryer
Masking tape
Sponge

This is the kind of painting I love doing, yet it is the most difficult. I cannot determine exactly what the final painting will look like, only the direction it will take. I depend on the painting to tell me what it needs as it grows. It is an exciting dance, an adrenaline rush. Of course there is the possibility of failure, but in painting you must accept a certain amount of failure as part of the growth process.

This painting is based on the forms of a Gothic cathedral. I have always been awed by the graceful arches and the wonderful stonework of this particular style of architecture. More than anything, the whole cathedral seems to be a visual symphony of rhythms. I wanted the painting to be a kind of Gothic hymn.

I began with a more passionate approach and no preliminary drawing, and then proceeded to a more methodical approach in which each stroke and each shape inspired the next addition. Toward the end it became a process: paint for five minutes and think for ten. As you will see, as elaborate as the painting is, it still consists entirely of washes and calligraphic brushstrokes.

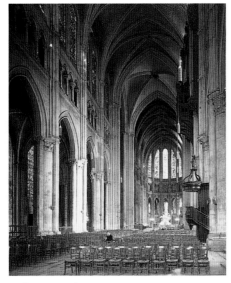

Reference Photo

1 Lay In the Initial Washes
For this painting, I decided against a smooth transition of graded washes because I wanted patches of color. The idea was to have the overall scene move from warm to cool, but with some interaction. Wet the entire sheet with water and, with a 2-inch (51mm) flat, charge into the wet with Quinacridone Gold, Quinacridone Rose, Quinacridone Sienna, Manganese Blue, Opera and Carbazole Violet, applying them vigorously with full arm movement. Don't create defined shapes of color; allow the colors to flow together. Blow dry these first washes.

WATERCOLOR DEMONSTRATION

117

2 Establish Arches and Gothic Forms

Load a no. 8 round with Quinacridone Gold and begin loosely drawing large Gothic arches. You don't need an exact plan. With each archway it becomes clearer where the painting is going. At this point I consulted a book on Gothic cathedrals and selected some of the most interesting features: rose window, lancet arches, tracery, sculptural figures, ribbed vaulting and quatrefoil designs. I chose a spot in the upper left for a rose window and drew it with a 6B pencil, adding other features spreading out from that point. This rose window is my personal visual concept, not a copy of any existing one. The same is true of the rest of the forms in the painting.

I added some of the shapes between the ribs in the vaulting on the right using a mixture of Carbazole Violet and Quinacridone Rose with a 1-inch (25mm) flat. I did the same on the left using Quinacridone Gold.

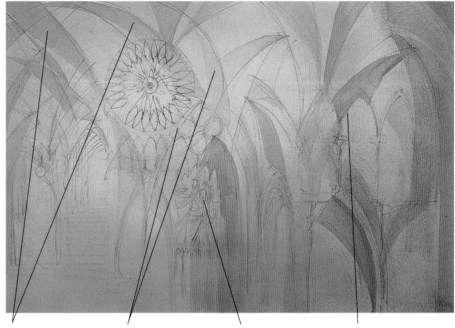

The ribbed vaulting provides additional rhythm, a kind of staccato version of the large arches.

To keep this rose window from being isolated, continue the circular movement with larger lines, to tie it in with the rest.

These figure statuaries, typical of Gothic cathedrals, add rhythm.

These lancet arches bring more rhythm to the right side.

3 Develop the Center of Interest

With a mixture of Quinacridone Gold and Quinacridone Rose, begin developing some of the forms in the rose window and the sculptural figures using a no. 8 round. Build arch forms around the figures with a mixture of Carbazole Violet and Quinacridone Magenta using a 1-inch (25mm) flat. Apply light washes of Quinacridone Rose to build more arch forms on the left.

With the center of interest established, you can see how far to go with the rest of the painting. Everything should be measured against the center of interest.

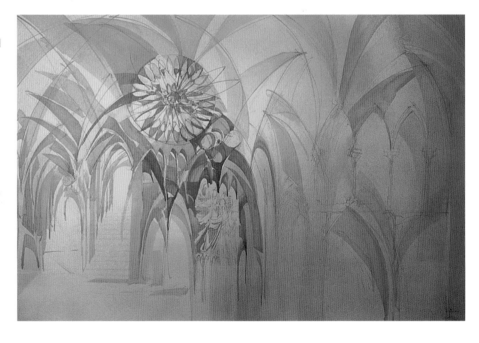

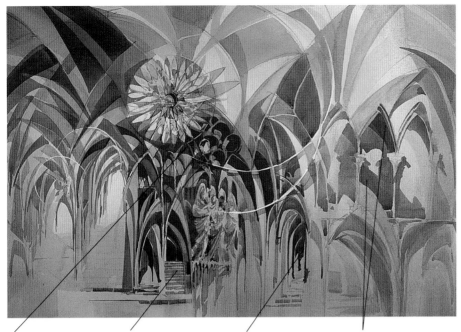

4 Develop the Value Pattern

The value pattern will provide a rhythm that holds the painting together. I wanted the pattern of darks to start high on the left and bounce across the paper, much like the series of arches as they move across the painting. Develop this rhythm with darker versions of the same colors.

On the right, I first studied the shadow shapes that were created in lancet arches and used those shapes to develop this area. I included a quatrefoil design just below and to the right of the rose window. To carry this circular rhythm through the rest of the painting, cut circular arcs in wide masking tape and position the tape to reveal only a thin line. Rub out the lines with a clean sponge. These circles are neither complete nor concentric, just repeat motifs.

Each dark adds to the overall value pattern and develops some architectural detail.

The horizontal steps add a counterpoint to the dominant verticals.

Shadow shapes in this area create a quatrefoil.

Unusual cast shadow shapes add to the value pattern while introducing a different kind of arch shape.

5 Add Final Details

Add the decorative detail. Pull the painting together by repeating the quatrefoil design in a few places and some tracery in a few of the arches. Notice that the farther away from the center of interest, the less finished the detail. Carry some of the Quinacridone Magenta into the stairs on the left side. The cool right side still seemed a bit separated from the rest of the painting, so I added some warm accents with Quinacridone Rose and Quinacridone Gold to tie it together more.

GOTHIC SYMPHONY
Watercolor
19" × 28" (48cm × 71cm)

Paint a street scene
as a GROUP OF SHAPES

<div style="writing-mode: vertical">WATERCOLOR DEMONSTRATION</div>

materials

PAPER

Arches 140-lb. (300gsm) rough

BRUSHES

Nos. 8 and 12 round

1-inch (25mm) flat

WATERCOLORS

Alizarin Crimson

Carbazole Violet

Manganese Blue

Permanent Rose

Quinacridone Burnt Orange

Quinacridone Sienna

Sap Green

OTHER

6B pencil

Sketchbook

Paper towels

I had been to Buckfast Abbey in Devon, England, a number of times, and so on this occasion I did not bother taking my sketch pad and I left my camera in the car. I was just taking the workshop participants there for a little shopping. As luck would have it, however, I walked past this archway—which I had not previously seen as a painting possibility—as two nuns were walking through it. That made all the difference! Now it was a painting.

I quickly returned to the car and grabbed my camera to take a picture of the archway with the wonderful shadow shapes surrounding it, assuming I would just have to remember the nuns. But it was my lucky day. As I got ready to snap the picture, another nun walked through the archway, giving me a reference for my subject.

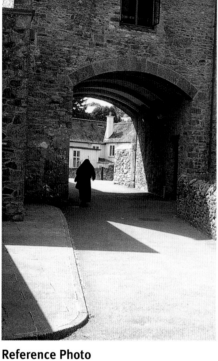

Reference Photo

Let's take this photo and make a value sketch, adding, eliminating and changing what we want in order to create a strong composition.

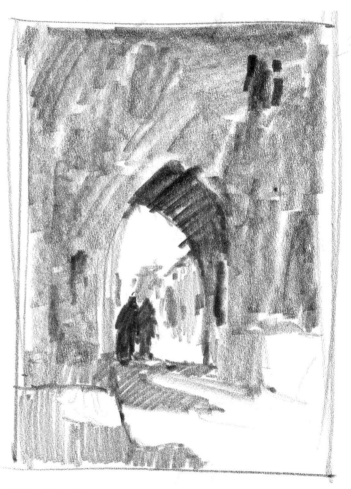

Value Sketch

Decide where you will put the lightest lights and the darkest darks and how to get the most effective use of shapes. The shape of the shadow is a definite plus, but I think a Gothic arch is more in keeping with the religious order of the nuns (and I simply liked the shape better). The window above the arch needs to be moved over to the right to balance the black shapes of the nuns. I rearranged the buildings in the background to make a street instead of a courtyard. Finally, I thought the wall needed some decoration to break it up, so I created a little niche with a figure. Now it is ready to paint.

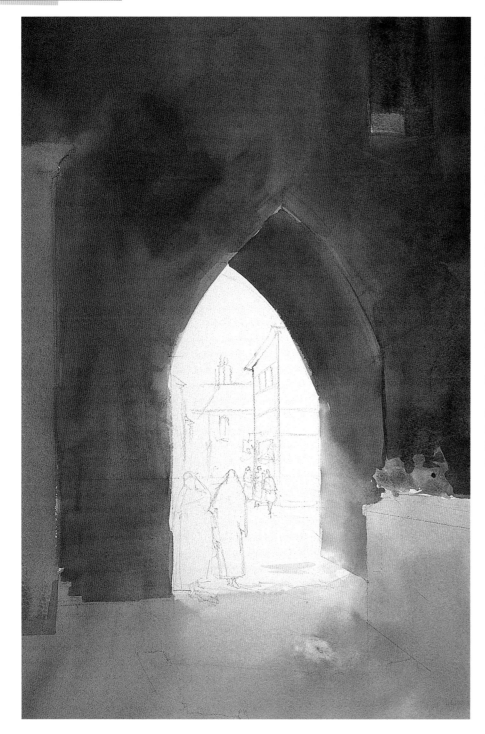

1 Lay In the Foundation Washes

Turn the paper upside down. Paint the lower left wall of the arch with a mixture of Quinacridone Sienna and Carbazole Violet, using a 1-inch (25mm) flat. Leave the strip of wall at the far left edge unpainted. While the area is still wet, pick up some Manganese Blue and paint the strip of the far left wall slightly lighter than the first wall. Add some Quinacridone Sienna as you go up. Then continue the first wash and as you near the top of the wall, use pure Quinacridone Sienna for a warm accent.

Drop in some Manganese Blue for the window as you continue the wash across the top of the arch wall, heading right using a your flat. Don't paint around the window and come back to it later because it will form a hard edge and will not merge with the wall. This is important because the wall edge is not a center of interest. Continue the arch wall down the right side using Carbazole Violet. Pop in a little Sap Green for the foliage on top of the wall.

Paint the underside of the arch with Quinacridone Burnt Orange, changing to Quinacridone Sienna and lightening the value toward the bottom. Paint the foreground a light wash of Quinacridone Sienna and Permanent Rose.

2 Add the Other Large
Foundation Shapes

The shadow shape is a mingled wash and must be done in one go, so use a 1-inch (25mm) flat and plenty of water. Begin at the left with Quinacridone Sienna to suggest warm light between the buildings. Add Carbazole Violet at the bottom left. Before the colors dry and give you a hard edge, pull the wash to the right and change to a mixture of Permanent Rose and Manganese Blue.

Add some spots of color for distant figures and flowers. Paint the forms of the background buildings, making shadowed sides face you. Suggest warm, reflected light under the eaves of the nearest building with some Quinacridone Sienna. This and the roof of the adjacent building will repeat the warmth of the foreground wall and help unify the piece.

Add some texture to the old wall. Spatter on some clean water first, then let it sit for a few seconds. Dab it off with a soft paper towel and immediately rub the area with a dry towel to lift off the spots. The harder you rub, the lighter they will be. Dab before wiping so that you will retain the shape of the spatter. Rubbing it immediately will smear the water and you will lift off a different shape.

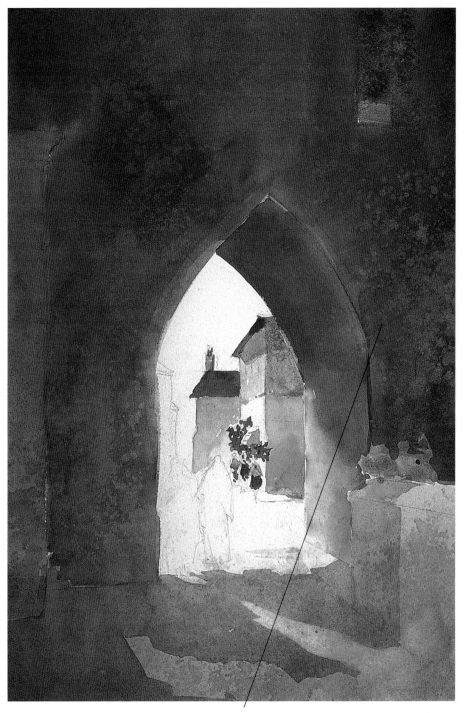

Don't try to distinguish between the wall and the shadow beyond it. Lost edges are part of our visual experience.

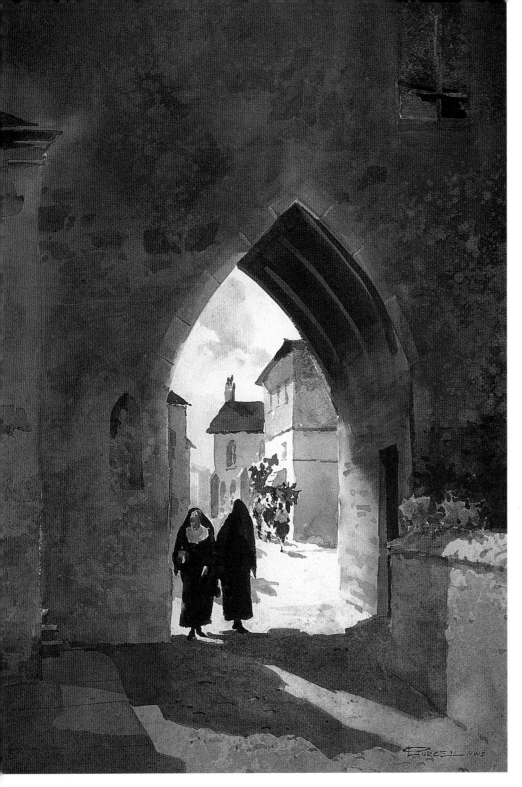

3 Add the Main Figures and Finishing Details

The figures in the archway are the center of interest, so reserve the sharpest detail, starkest value contrasts and strongest color for this area. Using a no. 8 round, paint the nuns' habits, but instead of black, which turns flat when dry, use Carbazole Violet, Alizarin Crimson and Quinacridone Burnt Orange. Apply a dab of Quinacridone Sienna for the face and Manganese Blue for the white vestment on the forehead and below the face.

Suggest the detail in the niche with a no. 8 round—just suggest, don't fully complete. With your flat brush, darken the cast shadow with a light wash of Carbazole Violet to define the walkway. Now add a little sky pattern in that beautiful space shape under the arch using your no. 12 round and Manganese Blue. Wet the brush and immediately soften the edges. Suggest the windows in the distant buildings with a no. 8 round.

Finally, using your fla brush, mix some Carbazole Violet and Quinacridone Burnt Orange and darken the underside of the arch, leaving the ribs. Lighten this wash a little as you bring it down the wall and across the doorway. Now add the door with the original dark mixture. With a no. 12 round, drag a few short strokes to indicate larger stones in the wall. Don't go too dark; just use the same color as the wall. The double layer will be dark enough.

COMING AND GOING AT BUCKFAST ABBEY
Watercolor
21" × 14" (53cm × 36cm)

POINTS TO Remember ☞

- A center of interest doesn't just appear, it results from planning.
- Strong value contrast is the most eye-catching and dramatic method for bringing out a center of interest.
- Color contrasts provide wonderful visual entertainment for the center of interest. Reserve your best shots of color for it.

- Don't expect the viewers to find their own way through the painting; direct them with lines of motion.
- Limit the visual activity of small shapes (details) to the areas of greatest importance. Keep everything else simple.
- You are the director; everything out there wants a part in your visual production. Use only the tools that best serve the needs of the painting. Then direct them to do what you want them to do.

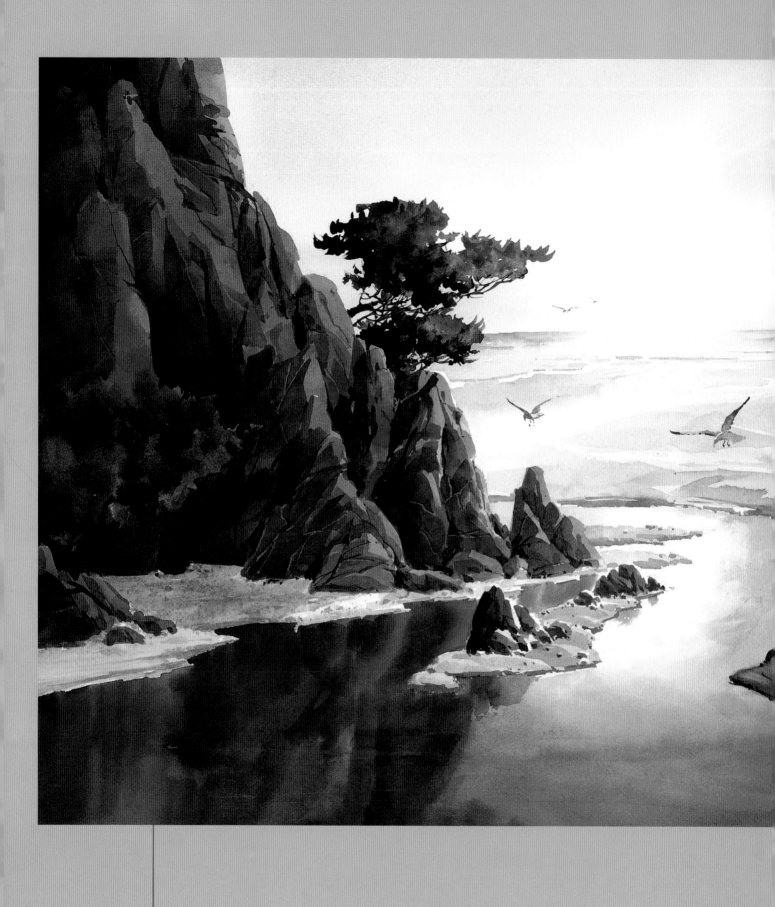

Conclusion

I doubt that anyone ever really masters watercolor—it is so elusive—but then again, that's what makes it so exciting. We have to be willing to accept a certain number of failures as part of our artistic development, because each so-called failure along with the successes gives us a little more courage to do the next painting.

Fear is our greatest inhibitor. Take a chance. Fear of trying a new approach will keep you confined in a comfortable prison of familiarity. A risk you take that results in a disastrous painting can teach you more than a thousand formula paintings. Embrace the heart-thumping fear that precedes every great painting. I recall a story of the pianist Arthur Rubinstein when he was in his eighties. Once he was reportedly warming his hands over a heater just before a concert when someone asked if he still got nervous before a performance. He replied, "Fear before every performance is the price I must pay for the marvelous life I lead."

When you feel that you are floundering in the middle of the painting, trust the voice inside to bring it to a successful conclusion. The excitement of watercolor painting is not in knowing all the steps from the beginning, but leaning on inspiration as you go. Don't try to paint one little item at a time in an effort to maintain control over the process from beginning to end. You may feel safe, but the painting will die before it is born.

Watercolor painting is like a dance that requires continuous motion. Enjoy the dance and try not to count the steps. Have fun as you keep pushing yourself and your art to greater heights.

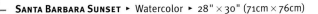

Santa Barbara Sunset ▶ Watercolor ▶ 28" × 30" (71cm × 76cm)

Index

The best in art instruction is from North Light Books!

Create alluring works of art through negative painting by working with the areas around the focal point of a composition. Through easy to follow step-by-step techniques, exercises and projects, you'll learn to harness the power of negative space. Linda Kemp's straightforward diagrams for color and design as well as trouble-shooting suggestions and secrets will make your next watercolor your most striking work yet!

ISBN 1-58180-376-1, hardcover, 128 pages, #32390-K

watercolor
painting outside the lines

a positive approach to negative painting
Linda Kemp

seeing the light
an artist's guide

Create depth, form and atmosphere with light in watercolor and oil

Betty Carr

CREATE YOUR OWN
Artist's Journal

Erin O'Toole

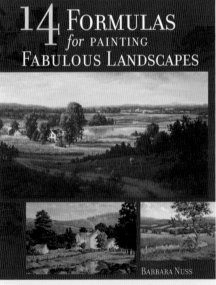

14 FORMULAS *for* PAINTING FABULOUS LANDSCAPES

BARBARA NUSS

By capturing the awe-inspiring qualities of light in your paintings, Betty Carr shows you how to create depth, form, mood and atmosphere in your watercolor and oil works. Twelve complete step-by-step demonstrations and close-up painting details help artists at all skill levels master light. You'll also find keys for "seeing" light and true color to bring vibrancy and life to each painting you create.

ISBN 1-58180-342-7, hardcover, 144 pages, #32312-K

Create your own artist's journal and capture those fleeting moments of inspiration and beauty! Erin O'Toole's friendly, fun-to-read advice makes getting started easy. You'll learn how to observe and record what you see, compose images that come alive with color and movement, and make a travel kit for creating art anywhere, at any time.

ISBN 1-58180-170-X, hardcover, 128 pages, #31921-K

Accomplished artist Barbara Nuss takes the guesswork out of capturing the beauty of the great outdoors. You'll learn to simplify, arrange and refine what you see in the natural world to create fabulous paintings. The 14 chapters cover each of the core design formats for landscape painting with easy-to-follow exercises, thumbnail sketches, photos and complete painting demonstrations. You'll gain the knowledge you need to link real-world natural scenes with these essential compositions for exceptional work.

ISBN 1-58180-385-0, hardcover, 144 pages, #32421-K